IMAGES
of America

BEDFORD-STUYVESANT

On the cover: The statue of Gen. Ulysses S. Grant on horseback, well known to local residents, marks the well-traveled intersection of Grant Square, a location where the major artery of Rogers Avenue converges into a single roadway with Bedford Avenue. In traversing between Flatbush and Bedford-Stuyvesant, the Bedford roadway approximates the original route of the long-forgotten Clove Road. Here it leads into the former site of historic Bedford Corners at the road's bend, marked by the crenellated 23rd Armory tower (left). (Courtesy of Brian Merlis.)

IMAGES
of America

BEDFORD-STUYVESANT

Wilhelmena Rhodes Kelly

ARCADIA
PUBLISHING

Published by Arcadia Publishing
Charleston SC, Chicago IL, Portsmouth NH, San Francisco CA

Printed in the United States of America

Library of Congress Catalog Card Number: 2006940155

For all general information contact Arcadia Publishing at:
Telephone 843-853-2070
Fax 843-853-0044
E-mail sales@arcadiapublishing.com
For customer service and orders:
Toll-Free 1-888-313-2665

Visit us on the Internet at www.arcadiapublishing.com

To a Brooklyn native, my grandmother
Wilhelmina Johnson Hamlin (1903–1930),
who lived and died in Brooklyn.
You are remembered.

CONTENTS

ACKNOWLEDGMENTS

My thanks go to the following people for their help with this book. First and foremost, I would like to recognize my sister Linda Rhodes Jones for her ready advice and helpful suggestions during the research and production of this book, as well as my mother, Dorothy Hamlin Rhodes, whose lifetime of Brooklyn experiences has helped me tremendously.

I would also like to thank Dolores McCullough for sharing her knowledge of Brooklyn history, her vintage photographs, and her patience in my use of her many irreplaceable documents. My special appreciation also goes to Rachael O'Connor, who shared her deep knowledge and understanding of the history of Native Americans and their Brooklyn presence, and her husband, Brooklyn native George O'Connor, whose personal reminiscences have helped fill in the gaps.

Appreciation also goes to the following friends, associates, historians, and fellow genealogists whose help was essential to the completion of this work: Julius and Joysetta Pearse, African Atlantic Genealogical Society; Fr. Pierre Dumas, St. Bartholomew's Anglican Church; Fr. Paul Jarvis, St. Peter Claver Roman Catholic Church; Jane Allen Shikoh, Daughters of the American Revolution; James Hurley, Brooklyn Historical Society; Pamela Green and Jennifer Scott, Weeksville Heritage Center; Dr. Marilyn Pettit, Brooklyn Historical Society; Anthony Wilkins; Elizabeth Harvey, Joy Holland, June Kuffi, Brooklyn Public Library; Leonara Gidlund, Municipal Archives for the City of New York; Sherri Smalls and Rev. Milton Gaddy Sr., Friendship Baptist Church; Debra Jones, Bedford Stuyvesant Restoration Corporation; Magnolia Tree Earth Center; Bettie Sam, Siloam Presbyterian Church; Dr. Robert Swan for his decades of valuable research; jazz aficionados Donald Sangster and Bill Hudson; Maria Cobo, Lefferts Homestead; Anna Belle, Concord Baptist Church of Christ; Alice Hudson, Map Room, New York Public Library; and the Brownstoners' Brenda Friarson.

INTRODUCTION

Bedford-Stuyvesant, located on western Long Island in Brooklyn, is one of the two largest African American communities in the United States, with the other being Manhattan's "Harlem, USA."

Named in the 1920s for the Bedford and Stuyvesant Avenues that mark its original east-west borders, it is an occasionally shifting grid of roughly 2,000 acres and housing more than 400,000 people. It is a stable community of beautiful churches and magnificent brownstones, and a great number of Bedford-Stuyvesant residents have lived or owned housing in the neighborhood for 70 years or more.

Remarkably, these residents are largely the descendants of the southern blacks who migrated north in the 1920s, 1930s, and 1940s in search of jobs, education, and equal opportunity. Their less-than-enthusiastic welcome at that time was not altogether unexpected, and it was that social conflict that helped mold the Bedford-Stuyvesant that we see today.

Once a simple farming community of approximately one square mile, this special locale was originally known as Bedford Corners and owns a deep pre–Revolutionary War history. Purchased from the Native Americans and settled by the Dutch in the 1660s, the place we call Bedford-Stuyvesant still bears traces of this heritage, even as it evolved and expanded into the major urban center we see today. This book focuses on the streets and landmarks of that original township and aims to share an overview of its dynamic history.

It is encouraging that researchers of late have taken increasing occasion to explore, recall, and even preserve our Brooklyn and Bedford-Stuyvesant history. This is in keeping with the prophetic words of Walt Whitman, who stated in 1861: "Still, there will come a time, here in Brooklyn, and all over America, when nothing will be of more interest than authentic reminiscences of the past. Much of it will be made up of subordinate 'memoirs,' and of personal chronicles . . . but we think every portion of it will always meet a welcome from the large mass of American readers."

Hopefully this small text will prompt a greater appreciation of historic Bedford-Stuyvesant and perhaps provoke deeper exploration of its noteworthy past.

One

EARLY HISTORY

In 1636, Dutchman J. Jacob Van Corlser acquired a parcel of land from the Kanarsee Indians and became, along with Andreis Hudd and Wolfert Gerritson, the first landholder of record in what would become Brooklyn. This trio of men would form New Amorsfoort, now known as Flatlands, the oldest and southernmost township in the borough.

Further north, in the following year of 1637, Joris Jansen de Rapalio (Rapalye) bought 395 acres on the Wallabout Bay, thereby creating the foundation of the original City of Brooklyn and future site of the Brooklyn Navy Yard. By 1640, a ferry was established that plied between present Fulton Street and Peck Slip, around which the Ferry settlement arose. A short five years later in 1645, Breuckelen Township, named for the ancient village of the same name in Holland, was established near today's borough hall. In time, the individual townships of Wallabout, Ferry, Gowanus, Cripplebush, Red Hook, and Bedford would unite to become the single district of Breuckelen.

In order to further protect the Wallabout settlement, the Dutch West India Company acquired woodlands from the Kanarsees, naming the township Bedford. This anglicized form of the Dutch word *Bestevaar*, when translated from the original Native American name, means "council place," or "place where the wise (old) men meet," a now-ancient recognition that native inhabitants once convened there.

In a 1662 grant, Jan Joris Rapalje, Teunis Gysbert Bogaert, Cornelius Jacobsen, Hendrick Sweers, Michael Hans (Bergen), and Jan Hans (Bergen) each acquired "20-morgen" (40 acres) of land for cultivation. These purchasers were the first of many who contributed to the early growth of Bedford Township.

On December 17, 1668, construction of the first public building was approved. On that day, Thomas Lambertse of Bedford was allowed to open a public tavern, "to accommodate strangers, travelers and other persons passing this way with diet and lodging and horse meals." Records show that Leffert Pieterse, a farmer from Flatbush Township, purchased land in Bedford from Thomas Lambertse in 1700.

Lefferts family members would continue to expand their landholdings to become one of the wealthiest and most influential families in Brooklyn, while Bedford slumbered on as a quiet agricultural town.

The Revolutionary War, however, would change all that. On August 27, 1776, the Battle of Long Island (also known as the Battle of Brooklyn) marked the first and bloodiest battle of the war. By forcing local resident William Howard to lead the way through a long ridge of wooded hills, 10,000 British soldiers traveled to Bedford then headed south on the Clove Road to surprise Washington's 7,000 troops.

Britain's victory over the patriots caused the outnumbered Gen. George Washington to evacuate Long Island under cover of fog and night, later to fight successfully at other locales. This initial loss resulted in seven years of British occupation in New York and Brooklyn from 1776 to 1783. The wealthy families of Bedford, including the Lefferts, Couwenhovens, Blooms, Van Endens, Suydams, and Vanderbilts, were made to shelter British officers during this time. In later years, Judge Leffert Lefferts frequently recalled his experiences as a boy during the occupation.

The Lefferts house actually served as headquarters for the officers, while the foot soldiers and mercenary Hessian troops lived in excavated barracks. Located between Franklin and Classon Avenues, the camp entrance was at today's Bergen Street and Franklin Avenue. Numerous wooden huts ran from Bergen, Wyckoff (St. Marks Place), Warren (Prospect Place), Baltic (Park Place), and Butler (Sterling) Streets and measured 30 feet by 50 feet long and 12 feet by 15 feet wide. The cabins each rested on a bank formed by excavated earth, were entered through a middle entrance, and were warmed by a stone fireplace. Many relics from that period have been found on this site, and no doubt many would still be today.

Skirmishes of war included frequent unexplained fires, which forced the local families to live in fire-damaged hulls. Just prior to the Battle of Brooklyn, early town records from 1700 to 1776 were stolen by assistant town clerk John Rapelye from town clerk John Lefferts's home and removed to England. They remain permanently lost. The torturous mistreatment of American patriots aboard the dozen British prison ships moored in the Wallabout Bay cost the lives of an estimated 8,500 to 11,500 black, white, and Native American sympathizers.

The signing in Paris of the Provisional Peace Treaty in 1782 signaled the approaching end of the war, and the occupiers assessed the primeval forests of Brooklyn and Queens for many cords of wood to be shipped to England. Hardly a tree, with the exception of a small piece of Tory-owned oak woods, escaped the ax. When the British finally left the island on November 25, 1783, there was virtually not one tree in Brooklyn that predated the Revolutionary War.

In a final gesture at their 1783 departure, a Union Jack was nailed to the top of a greased wooden flagpole, and a single but ineffective parting salvo was released by the British as they left Manhattan's Battery Harbor. Legend has it that after a number of thwarted tries, the pole was finally scaled by John Van Arsdale, a prominent soldier in the Revolution, who through the use of cleated shoes replaced the American flag within the sight of the British before they left harbor.

Some British loyalists, however, remained. Charles Turnbull, an officer in the British service, bought and renovated a home at what is today's Arlington Place at 1224 Fulton Street. Purchased by Judge Leffert Lefferts in 1791, it later became the last Revolutionary War house in Bedford until it was demolished in 1909.

But for many years, Americans remembered the war, and for nearly a century, the November 25, 1783, date was celebrated in the Brooklyn and New York area as Evacuation Day with activities that included the firing of cannons and the hoisting of the American Flag in Manhattan's Battery Park. It was not until World War I that animosities between the two countries were ended.

The years following the Revolution were ones of intense labor for Bedford. Restoring damaged homes, clearing and reforesting the woods, and growing food for consumption and sale were some of the tasks in need of attention, much of which were performed by Bedford's 72 resident slaves, a population totaling one quarter of 204 Bedford residents shown on America's first census in 1790.

Throughout the ensuing years, people of color would consistently average a 25 percent representation in nearly all of Brooklyn's local populations.

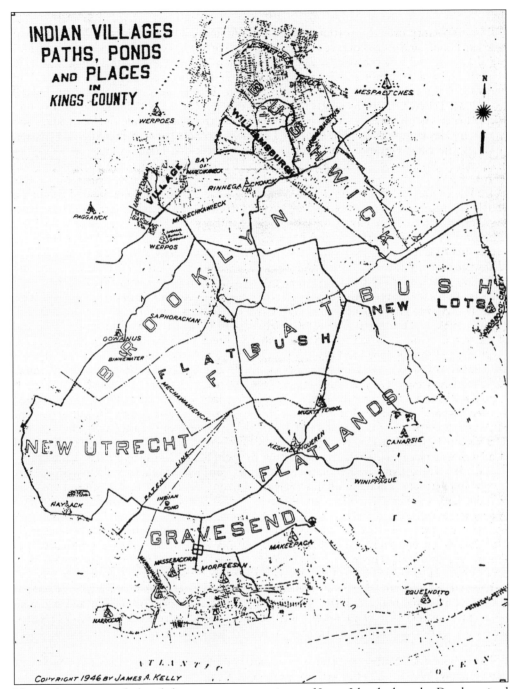

Native Americans inhabited the westernmost territory of Long Island when the Dutch arrived in the future township of Brooklyn in 1642. In time, the deep ponds would be filled and the soaring hills leveled, but the network of native pathways would become the foundation of major streets and arteries found in Brooklyn today.

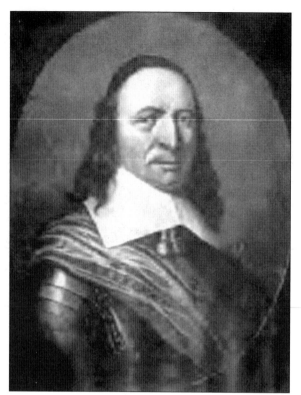

Peter Stuyvesant (born in 1592) served as the last Dutch governor of New Netherlands from 1647 to 1664. During his 17-year rule, Stuyvesant left his mark on Brooklyn's street grids, roadways, and cemeteries. Stuyvesant Avenue, one of the streets marking the earliest (and constantly shifting) boundaries of the Bedford-Stuyvesant neighborhood, was named for the influential governor.

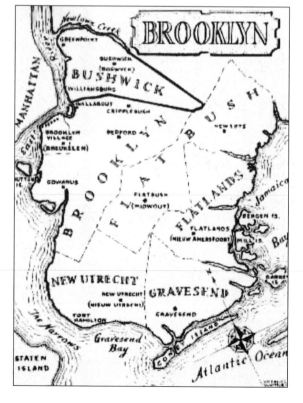

Initially settling along the coastline opposite Manhattan Island, by 1683 the five separate Dutch townships of Brooklyn, Flatbush, Flatlands, Bushwick, and New Utrecht, as well as the English settlement of Gravesend, occupied the territory that became the Brooklyn known today. Bedford-Stuyvesant is rooted in the young township of Bedford shown here.

Gen. Israel Putnam was sent by Gen. George Washington up Jamaica Plank Road to determine the advance of British and Hessian soldiers. It is reported that by going to the roof of the Rem Lefferts mansion (at today's Arlington Place), the dust of the approaching armies of General Howe and General Cornwallis could be seen from neighboring East New York, thus allowing America's patriot army earlier preparation.

British lieutenant general Sir William Howe defeated George Washington's army, which was led by Maj. Gen. Israel Putnam on August 27, 1776. Known as the Battle of Long Island, it resulted in Britain's capture of New York City and Long Island, which they held until Evacuation Day, November 25, 1783. This date remained a major New York holiday until the start of World War I.

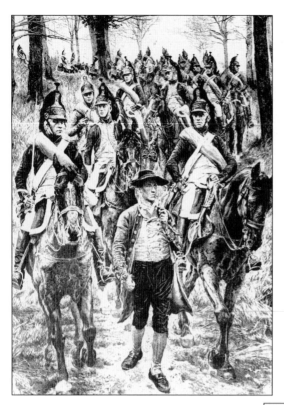

Inn keeper William Howard and his 14-year-old son, the future American major William Howard, were forced at 2:00 a.m. on August 27, 1776, by British general Howe to show him and his army the Jamaica Pass through the wooded hills of Brooklyn. A full and detailed rendering of this encounter can be read in the *Manual of the Common Council* compiled in 1868 by Brooklyn city clerk William G. Bishop.

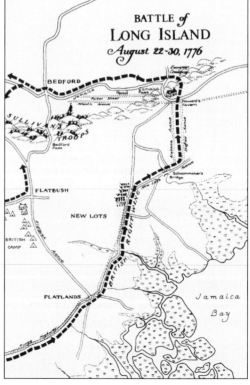

The Battle of Brooklyn, also known as the Battle of Long Island, was the first battle ever fought by the United States. It was also the first and largest battle of the Revolutionary War. The British marched through this Jamaica Pass (shown east of Bedford) to surprise Washington and ultimately force the August 30 retreat and evacuation of his 7,000 troops from the island.

A glacial moraine formed the steep hills of Brooklyn shown on this 1841 map of western Long Island. Grid lines mark the well-populated towns of Brooklyn and Williamsburgh, with Bedford (at the map's center) only a tiny hamlet. Travel south from Bedford, regardless of the route taken, was made through formidable hills, as shown.

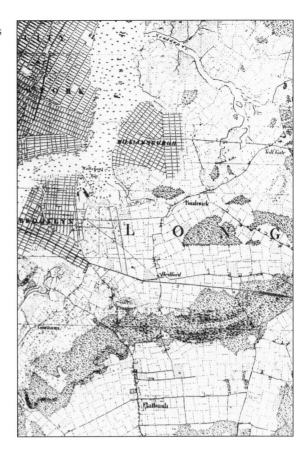

The well-appointed homes of many prominent Bedford residents were commandeered by the British with the August 30 capture of New York City and Long Island. These included the residences of the Lefferts, Suydem, Tiebout, Cowenhoven, Remsen, and Lott families that dot this Bedford map.

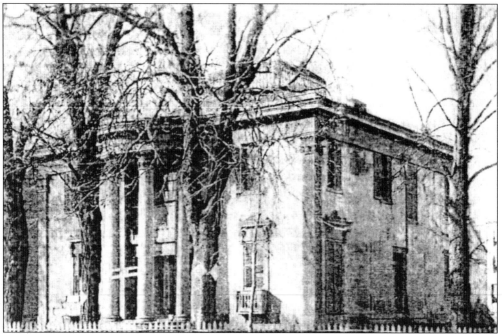

Britain's army reportedly halted in front of the Rem Lefferts house on its march down the Jamaica Plank Road (today's Fulton Street). Here Generals Howe and Cornwallis paused to decide whether to continue west toward Fort Greene or turn left at Bedford Corners to follow the Old Clove Road toward Flatbush, which they ultimately decided to do. Battle Hill at Greenwood Cemetery today marks this bloody event.

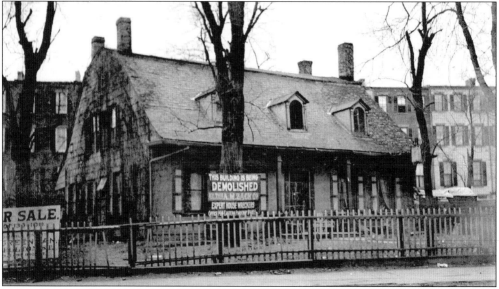

Following the war, not all opposing army troops abandoned New York. In 1787, British officer Charles Turnbull rebuilt an old Dutch farmhouse and later sold it to Leffert Lefferts in 1791. Located on the site of 1224 Fulton Street, between Nostrand and Bedford Avenues, an antique furniture dealer occupied it until it was taken down in 1909. (Courtesy of the Brooklyn Historical Society.)

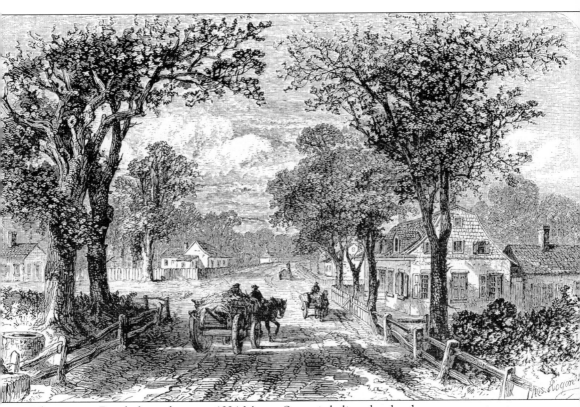

The ancient Dutch frame home at 1224 Macon Street is believed to be the very same structure depicted in the woodcut rendering of *Bedford Corners in 1776* listed in Henry Stiles's book *A History of the City of Brooklyn*. The 1909 removal of this house destroyed the last vestige of pre–Revolutionary War architecture once common in the old hamlet of Bedford.

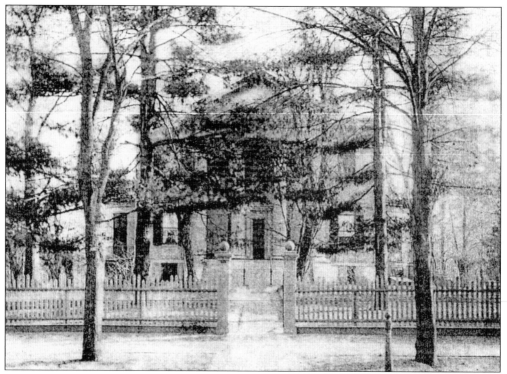

The homestead of Rem Lefferts, built by Jacobus Lefferts in 1768, was torn down in June 1893. Once located at today's Fulton Street and Arlington Place, the mansion had doors of solid mahogany, windows reaching from floor to 10-foot ceilings, doorknobs of solid silver, and fireplaces large enough for an average-sized man to walk into without stooping.

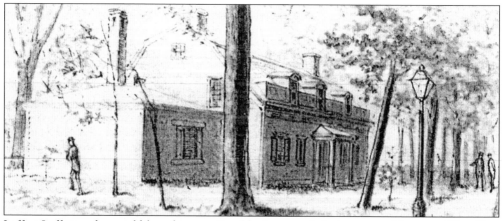

Leffert Lefferts, who would later become Brooklyn's town clerk, lawyer, and keeper of Brooklyn records, was forced to house the British throughout the duration of the war, during which time Lefferts, then a young boy, came to know the opposing officers well. This pre–Revolutionary home, at the northwest corner of today's Fulton Street and Bedford Avenue, was demolished in 1877.

Two

CHURCHES

From Brooklyn's earliest founding, the church remained the major anchoring force behind its successful settlement and expansion. A source of spiritual guidance, it was a galvanizing element in unifying the thoughts, purposes, and living standards of its earliest residents.

The influence of the Dutch church is clear in the construction of Brooklyn's earliest buildings, typically designed in the sturdy gabled style of the Netherlands and often trimmed in terra-cotta of Dutch import.

A number of images still exist of the first Dutch church that once stood in great and symbolic predominance at the crossroads of Duffield and Fulton Streets in downtown Brooklyn, today near the former Abraham and Straus department store (now Macy's). The Flatbush Reformed Church in the early town of Flatbush is another example of early Dutch settlement. Built in 1799, and set on an earlier 1654 foundation, it remains to this day at the crossroads of Flatbush and Church Avenues, with the ancient tombstones of Revolutionary War soldiers still shaded in its churchyard.

Even when the British took New Amsterdam in 1665, it was not until 1792 that the English language was introduced into the regular Dutch Reform services.

In Bedford, the influence was still present as late as February 15, 1843, when the East Reformed Dutch Church was organized, headed by Rev. John W. Schenck. A replacement edifice was erected in 1875 on the corner of Bedford Avenue and Madison Street at a cost of $140,000. By 1887, 30 master Masons with the Aurora Grata Lodge of Perfection (established in 1806) bought the original church building at 1160 Bedford Avenue and turned it into a Scottish Rite Cathedral.

By the 1880s, a lacy skyline of spectacular church steeples beautified the town of Bedford, and its churches had diversified into a number of varying denominations and religions, including Presbyterian, Congregational, Puritan, Quaker, Anglican, Lutheran, Catholic, Methodist, Baptist, and Jewish. Soaring examples included the Puritan Congregational Church located on the corner of Lafayette and Marcy Avenues, Our Lady of Victory on Macon Street and Throop Avenue, the German Reform Church on Bedford Avenue near Lafayette, and the Marcy Avenue Baptist Church on Marcy and Putnam Avenues.

Brooklyn by this time was already recognized as the "City of Churches," a deserved title given its number of structures and attendees. On May 29, 1884, Brooklyn's Sunday School Union celebrated its 52nd anniversary of existence with an annual parade along Bedford Avenue that included 50,000 children, Sunday school officers, and teachers. The union was organized in 1816 to "provide free religious instruction for the borough's children," with four parading churches comprising its first line in March 1829.

Although the records conflict regarding its founding, one common belief is that Brooklyn Sunday School Union was founded by Isabella Graham in 1803 to teach reading, writing, and religious instruction.

Another states that Sunday school instruction in New York was first provided by Catherine Ferguson (1779–1854), a freed Virginia slave who sought to provide the poor with basic education. In 1814, from her home at 52 Warren Street in downtown Brooklyn, Ferguson reportedly cared for homeless, hungry urchins who "ran the streets on the Lord's Day."

Regardless of which record one wants to believe, the fact remains that in 1816 the practice of a Sunday school education was born, a service that over the years grew into a huge religious institution.

Many of the oldest and largest black churches located in Bedford-Stuyvesant today were founded in Brooklyn's downtown area near Ferguson's residence. Located close to the Brooklyn Ferry, the churches of Bridge Street African Methodist Episcopal (established in 1766), Siloam Presbyterian (1849), and Concord Baptist (1847), to name a few, all had their start downtown.

Their locations near the waterfront no doubt contributed to the role these churches would play in the Underground Railroad, which they did by regularly providing a safe haven for slaves escaping to Canada. White abolitionists also worked in tandem with these churches, often assisting in the transport of these men and women by sheltering them in their own sanctuaries. Nearby Plymouth Church, for one, is known to have helped in this way; and Emanual Baptist Church, further inland on Lafayette Avenue, as another.

Eventually, with the Fulton Street elevated train service in 1885 and increases in modes of public transportation, many church members moved "uptown" to the black neighborhoods of Weeksville and Carrville in Bedford's Ninth Ward. Some took less desirable apartments under the noise and rumble of the Fulton Street trains, and others moved to Atlantic Avenue near the clanging of the Long Island Railroad. Although noisier, these new quarters were an improvement over the older and increasingly dilapidated housing of downtown.

By the 1920s and 1930s, the old African American churches had followed their congregation to new homes in Bedford-Stuyvesant. As the black population of Bedford began to expand, discrimination showed itself as white residents left the neighborhood rather than share it with newcomers from the American South or the Caribbean.

As a result, many local church buildings went up for sale and a number of formerly Congregational, Lutheran, and German churches were replaced by African Methodist Episcopal (AME), Baptist, Episcopal, and AME Zion groups.

The local Roman Catholic diocese also resisted integration and built a special church for its local black worshipers. St. Peter Claver Church, located near Franklin Avenue and Fulton Street, was named for Pedro Claver (born in 1580) of Cartajana, Columbia, a black saint who was martyred in 1654. It was dynamically led by Fr. Bernard J. Quinn who brought Christian devotion and commitment to the fledgling church. Under his leadership, membership grew and prospered. In 1929, church member Fr. William Rodgers became the first black Roman Catholic priest to be ordained in Brooklyn.

St. Bartholomew's Anglican Church on Pacific Street and St. George's Episcopal Church on Marcy and Gates Avenues became predominantly Caribbean congregations by the 1940s, and the maintenance of the beautiful structures and commitment to the church never faltered. Like the Dutch founders, the black church, including those in Bedford-Stuyvesant of the last 75 years, has remained the oldest and most influential institution in African American life.

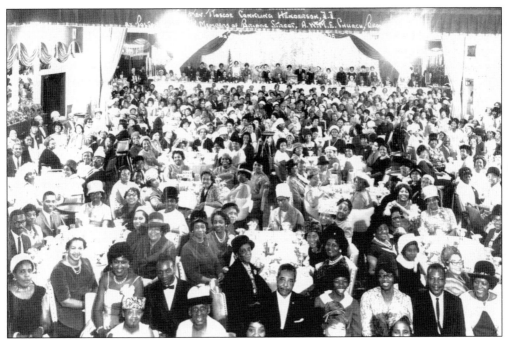

This huge commemorative luncheon underscores the excellent growth and unwavering support enjoyed by Bridge Street AME Church over the years. This 1965 image captures only a portion of the panoramic attendance of the congregation on that day.

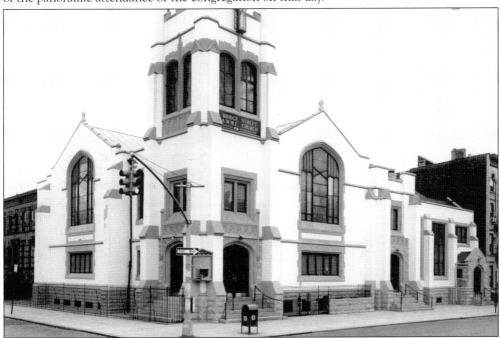

As commercial establishments continued to move into the residential areas around Bridge Street, and most church members moved further uptown, the decision was made to purchase the Grace Presbyterian Church at 273–277 Stuyvesant Avenue at Jefferson Avenue where the church has resided since 1933.

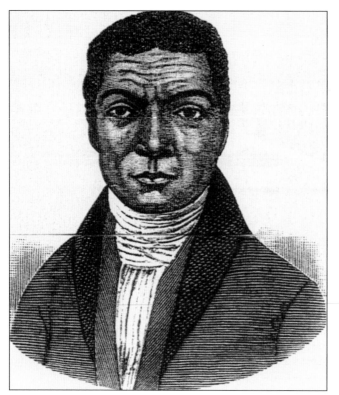

Christopher Rush, born in 1777, was brought as a slave from North Carolina to New York in 1798. He joined the AME church in 1803, gained his freedom in 1812, and was licensed to preach in 1815. Named an AME bishop in 1823, he lived to be 96 years of age and remained a significant force in the church despite going blind 14 years before his death.

Recognized as the oldest African American church in Brooklyn, Bridge Street AME Church (established in 1766) is shown here at its Bridge Street location, once a stop on the Underground Railroad. The church moved to Bedford-Stuyvesant in 1938.

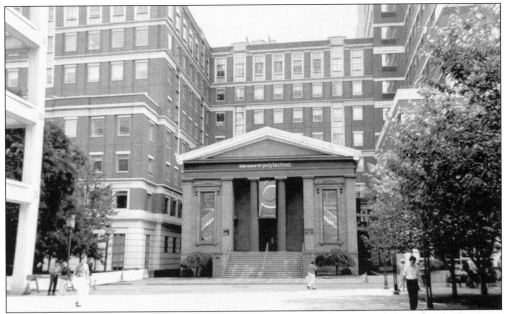

In 1990, JP Morgan Chase Bank leveled many city blocks of historic downtown Brooklyn to create the huge commercial Metrotech Center. Today Polytechnic University occupies the former Bridge Street AME Church structure, a designated landmark that is now in a pedestrian mall and functions as one of the school's administrative buildings.

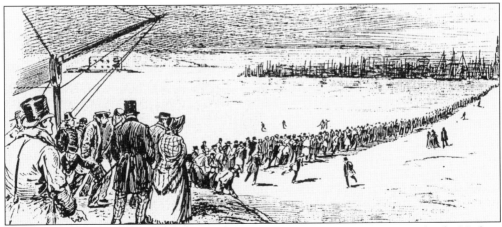

Years ago, long before the phenomena of global warming, it was not uncommon for the Hudson River to freeze solid, thereby creating a virtual land bridge between Brooklyn and Manhattan. Here, in 1852, scores use the only means of transportation available to them, they "walked the river."

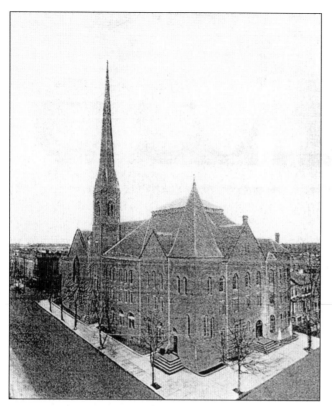

Since most of its congregation had moved from downtown to central Brooklyn, the Concord Baptist Church of Christ purchased the Marcy Avenue Baptist Church in 1939 and relocated to its present site at Marcy Avenue between Putnam Avenue and Monroe Street. This 1872 edifice burned down in 1952.

Once the tapered spire of Concord Baptist church and the Boys High School bell tower on Marcy Avenue dominated the Bedford skyline. On October 3, 1952, an electrical fire burned the church to the ground. As the fire raged, firemen constantly doused the school with water to prevent it from also going up in flames.

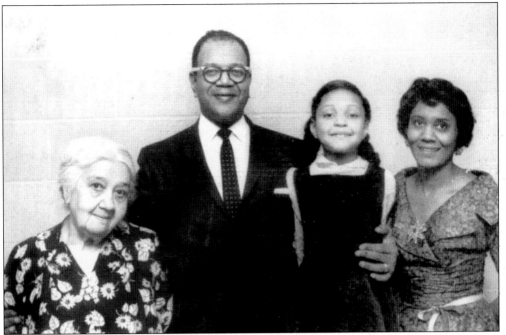

Rev. Dr. Gardner Taylor successfully led the Concord congregation through the tough rebuilding process. Here in the 1950s, Taylor is surrounded by family, his mother, Selena Taylor; his daughter, Martha; and his wife, Laura Taylor. He retired as senior pastor emeritus in 1990 after 42 years of service.

The Rev. Dr. Milton Galamison brought tremendous growth to Siloam Presbyterian Church following his installation in October 1948. A noted social activist, Galamison over the next 40 years achieved equal rights for people of color in Brooklyn, while also expanding the scope and accomplishments of the church body. (Courtesy of Bettie Sam, administration, Siloam Presbyterian Church.)

In later years, the huge Brooklyn Day event was broken into smaller components, and the numerous church Sunday schools, Girl Scout, Boy Scout, Brownie, and Cub Scout troops marched through neighborhood streets. Here a Bedford-Stuyvesant participant still wears her parade sash proclaiming, "Christ The Prince of Peace."

In 1956, two members of the Concord Baptist Church of Christ Sunday School, Linda Rhodes and Wilhelmena Rhodes, were photographed before joining the Brooklyn Day march from Nostrand Avenue to Stuyvesant Avenue along Jefferson Avenue.

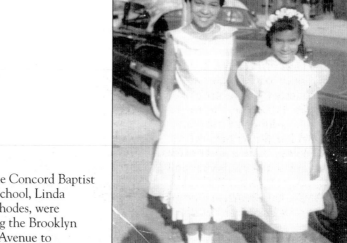

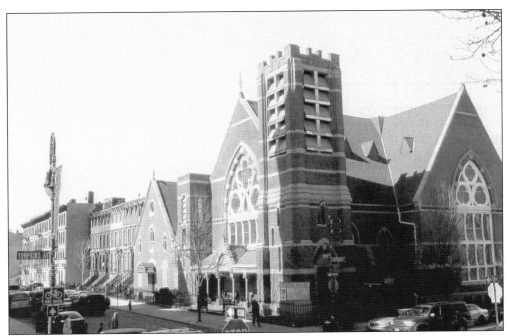

The First AME Zion Church also shares a history with this Stuyvesant Heights Christian Church shown here (and across the street in far right below). The AME Zion church once owned the Stuyvesant Heights building before deciding in 1889 to build the huge brick and steepled structure designed by the renowned architect George B. Chappell.

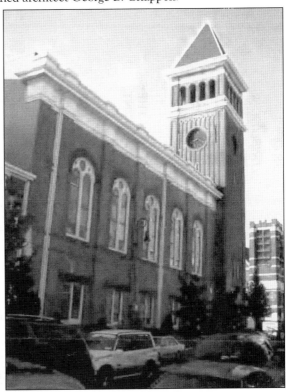

The old Fleet Street AME Zion Church, once located near the Brooklyn ferry terminal, collapsed in February 1905 under the weight of worshipers during the funeral of popular bandleader Sidney L. Pointer, killing more than 11 people. It moved to Tompkins Avenue and MacDonough Street in 1947 as the First AME Zion Church and bears a Fleet Street Memorial Church inscription on its cornerstone in recognition of its downtown roots. (Courtesy of Tom Fletcher.)

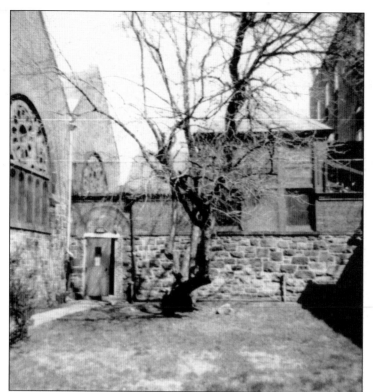

In the 1830s and 1840s, locust trees lined the old Clove Road that linked the towns of Bedford and Flatbush. This ancient tree, a remnant of that time, now sits in the courtyard of St. Bartholomew's Anglican Church, an edifice constructed in 1886 on the old Clove Roadway (at today's Pacific Street near Bedford Avenue). A close examination of its gnarled trunk dispels any doubt of its significant age.

Under the leadership of the Reverend Frank M. Townley the rectory was built in 1912, an endowment fund was started in 1918, and the community house was built during 1919–1920. A recognized landmark in 1975, the church is enhanced by 15 exquisite Tiffany stained-glass windows. (Courtesy of Rev. Pierre Damus, St. Bartholomew's Anglican Church.)

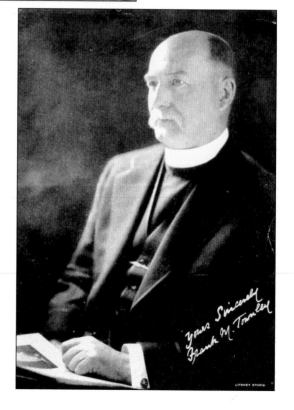

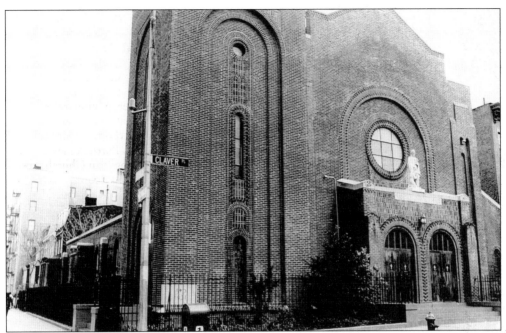

St. Peter Claver Roman Catholic Church, founded in the neighborhood and named for a black saint, was created specifically for a black congregation since they were often denied admittance to local Bedford-Stuyvesant Catholic churches prior to the 1920s. Before reconstruction work was completed on the church building at Claver Place and Jefferson Avenue, a gathering of the first Sunday school took place at 389 State Street. (Courtesy of Fr. Paul Jarvis, St. Peter Claver Roman Catholic Church.)

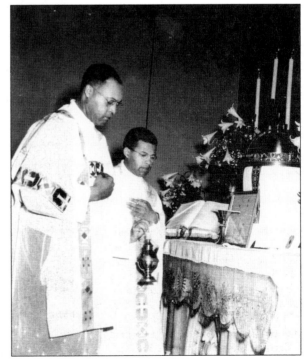

On June 11, 1949, Rev. William Rodgers (right) became the first black Roman Catholic priest ever ordained in Brooklyn. The ordination took place at St. James Pro-Cathedral at Jay Street and Cathedral Place. Here Father Rodgers celebrates his first mass. (Courtesy of Fr. Paul Jarvis, St. Peter Claver Roman Catholic Church.)

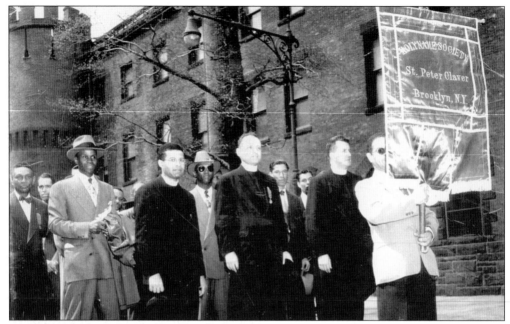

Here the Reverend William Rodgers (left) marches past the 23rd Armory located at Bedford Avenue to attend a rally in downtown Brooklyn to raise public awareness of the mistreatment of a fellow priest in another country. (Courtesy of Fr. Paul Jarvis, St. Peter Claver Roman Catholic Church.)

Despite landowner opposition to the construction of yet another area Catholic church, the parishioners of 1868 saw this many pinnacled Gothic Revival church become a reality. Located on Throop Avenue and MacDonough Street, and designed by Thomas F. Houghton, plans are to unite Our Lady of Victory with two other local congregations: St. Peter Claver and Holy Rosary Church in 2007.

The Reverend John W. Hamlin, born in 1870 in Dinwiddie, Virginia, became the new minister of Mount Lebanon Baptist Church in 1916. Under his leadership of 21 years, church membership increased from 75 to over 1,000, and in 1921 he cofounded the Eastern Baptist Conference, which today is still dedicated to furthering Christian education.

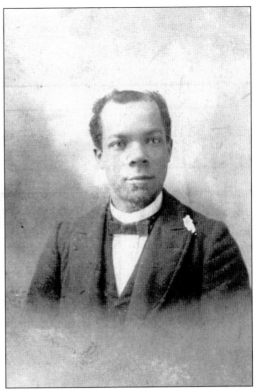

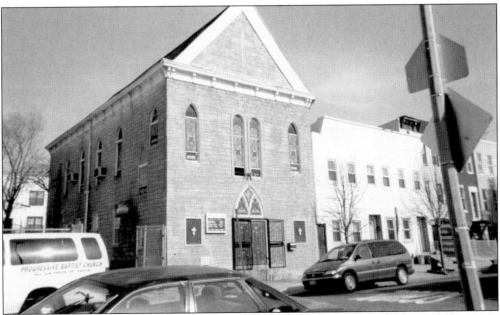

This original edifice of Mount Lebanon Baptist Church still stands on Howard Avenue near Atlantic Avenue in Brooklyn's old Ninth Ward. Today Progressive Baptist Church calls this building home. Under the Reverend Dr. Claude F. Franklin Jr.'s leadership, Mount Lebanon moved into a now-landmarked Romanesque structure at 228 Decatur Street in 1938, where it has remained for the past 70 years.

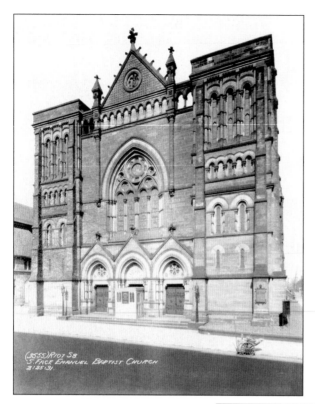

Emmanuel Baptist Church at 279 Lafayette Avenue, founded in 1881, is an offshoot of the Washington Avenue Baptist Church at Washington and Gates Avenues. The First Williamsburgh and Marcy Avenue Baptist Churches each merged with Emmanuel in the 1920s and 1930s, and in 1975, Dr. H. Edward Whittaker became its first black minister, adding spirituals and gospel music to the service. In 1981, the Landmarks Preservation Commission called it "perhaps the finest surviving 19th century church interior in New York City." (Courtesy of Brian Merlis.)

In 1860, Orthodox Friends began meeting in rented space at Packer Collegiate Institute, and by 1868 it had its own meetinghouse at the corner of Washington and Lafayette Avenues (shown here). The church soon established monthly meetings and was then called Brooklyn Congregational Meeting, later known as Brooklyn Friends Church. In 1959, citing changes in the local population, it merged with Brooklyn Friends at its downtown meetinghouse on Schermerhorn Street and Boerum Place. Built in 1857, they still meet at that building today. (Courtesy of Brian Merlis.)

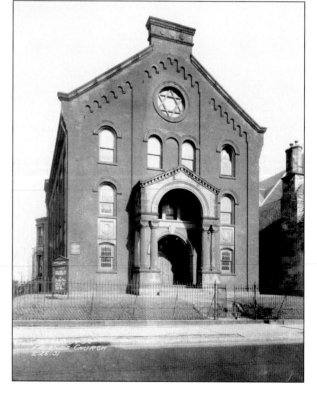

The Mormons were also represented in the Bedford-Stuyvesant community. The Church of Jesus Christ of Later Day Saints purchased the 265 Gates Avenue property on July 5, 1916, and a chapel was built in 1918. The Evening Star Baptist Church now resides in this building.

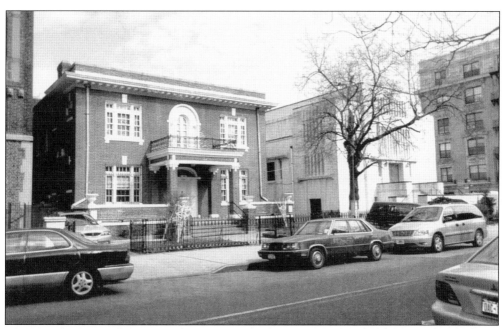

The Church of Jesus Christ of Later Day Saints Ward Home is next door at 267 Gates Avenue near Franklin Avenue. The property was purchased from Carrie B. Post on July 6, 1916, and the home was built in 1917. This structure is also presently owned by the Evening Star Baptist Church.

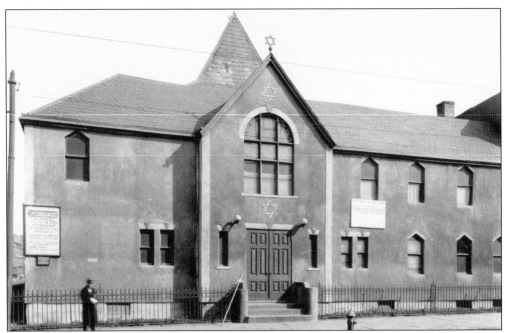

A Jewish synagogue stood on the corner of Marcy Avenue and Park Avenue in the Bedford-Stuyvesant of the 1930s. The neighborhood at that time was mixed with Italians, Jews, Germans, and Irish, with a tailor, butcher shop, Italian bakery, barbershop, and drugstore in the surrounding blocks. Today the site is a multiblock housing development. (Courtesy of the New York Historical Society.)

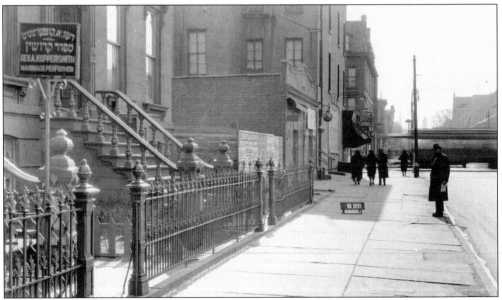

In 1929, a "Marriages Performed" sign inside the gate near Marcy and Park Avenues is lettered in both Hebrew and English, as a trolley becomes a blur just a few doors away. Notice the billboard advertising the latest offering at the Loew's Brevoort theater, and the distantly faint spires of Boys High School and the Marcy Avenue Baptist Church. (Courtesy of the Municipal Archives of the City of New York.)

Three

SCHOOLS

Research reveals that the first free school ever founded in America was established in Brooklyn on July 4, 1661. On that date, Dutch governor Peter Stuyvesant ordered an appropriation of 50 guilders from the public treasury to supplement the first school tax levied in Breuckelen for the education of the village children. The first schoolhouse was reportedly located at today's Fulton and Bridge Streets near 110 Livingston Street, home to the board of education from 1939 to 2002.

A second school was established in 1662 in Bushwick under Stuyvesant's direction located near the intersection of North Second Street and Bushwick Avenue.

Bedford established a third school in 1663 at the junction of the old Clove and Cripplebush Roads, or what is now the corner of Bedford Avenue and Fulton Street. Teacher John Vandevoort, who taught three generations of pupils during his 60-year tenure, occupied one-half of the building as an apartment. He was allowed to enlarge the building by adding a 14-foot-by-14-foot room from which to sell groceries to supplement his income.

A schoolhouse was built on the village green in 1721, bounded by Bedford, Franklin, and Atlantic Avenues and Fulton Street. Instruction in all schools was given in Dutch until 1758, with a choice of Dutch or English between 1758 and 1800.

In 1810, the schoolhouse was replaced by a new one, and in 1830, another was built across the road on the east side of the Cripplebush Road. Also a one-story structure with two rooms, one was designated for young children and the other for the older.

This Bedford structure became Public School 3 when the board of education united the 10 village schools into one common system in 1843, the year schools fell within the jurisdiction of the city. The numerical designations of today's schools, except in only two or three instances, coincide with their actual chronology of founding.

When the English took New Amsterdam in 1665, the free school system was abolished, and for a century and a half the schools were supported solely by their patrons.

In 1843, the board of education was created by the common council, which directed two or more citizens to represent each district. They, together with the mayor and a county superintendent, formed the Board of Education of the City of Brooklyn.

In 1849, the City of Brooklyn took charge of the Bedford School and erected a new building on Bedford and Jefferson Avenues that opened in 1851, with the old structure rented for other purposes.

Prior to 1841, the African Free School was founded by blacks, but this system was taken over by the board of education in 1855 and renumbered by the board. These black schools

included Colored School No. 1 at Willoughby Avenue near Raymond Street, and Colored School No. 4 on High Street; Colored School No. 2 in Weeksville, today identified as Public School 243; and Colored School No. 3 (renamed No. 69 in 1887) in Williamsburgh. Today only the Williamsburgh structure still survives.

In 1884, the free book system was adopted by the education board, with books and slates furnished to every child at the city's expense.

By 1892, there was a training school where teachers could study and qualify by exam for higher grade certificates; a boys' high school and a girls' high school, 32 grammar schools, three of which were colored; 16 independent intermediate schools; and two attendance schools where truants were probated for a term, with the most troublesome sent to the truant home. This total of 87 schools is exclusive of the 15 evening schools established about 1850 for the working class, old and young, of both sexes. In that year, a total of 85,860 students were instructed by 2,186 teachers.

Two beautiful landmark schools presently grace the avenues of Bedford-Stuyvesant. The construction of Girls High School in 1885 was designed to handle the overflow of students then attending the coeducational Central Grammar School (1878–1886). Built in the Gothic Revival style, the new structure was not large enough to accept all the students, so a separate structure was made for the boys.

The Boys High School was completed in 1891 and designated a landmark in September 1975. Designed by James W. Naughton (1840–1898), the Romanesque Revival building contains 33 classrooms, and is situated on a half-acre plot.

Both schools are now part of the charter school program offering adult educational instruction and special training.

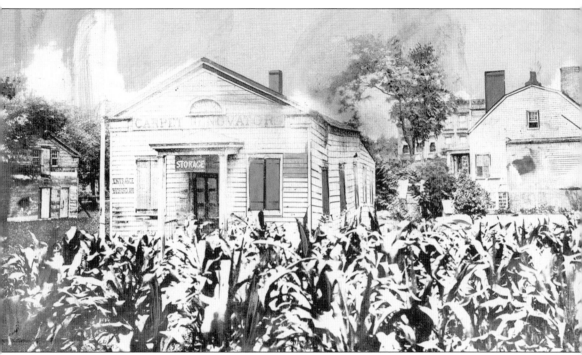

Public School 3, founded by the Dutch in 1663, was the first school in the new settlement of Bedford. The one-room schoolhouse pictured above was situated in a cornfield at Franklin Avenue and Hancock Street. On December 20, 1897, it served as the first public library under the $1.6 million Andrew Carnegie Plan to lend books free of charge to all who wished to read. (Courtesy of the Brooklyn Public Library.)

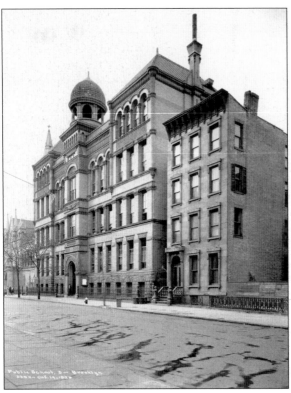

Architect James W. Naughton designed the Romanesque Revival building of Public School 3, as well as the nearby Boys High School at Putnam and Marcy Avenues, and Girls High School on Halsey Street. The 1891 elementary school was replaced in the 1940s by a more modern building. (Courtesy of the Municipal Archives of the City of New York.)

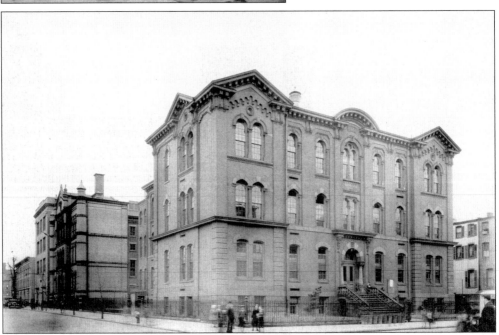

Public School 35, a magnificent Romanesque Revival building, once stood on the northwest corner of Lewis Avenue and Decatur Street. The Decatur School, as it was once known, was lost to the wrecker's ball in the 1950s and was replaced by a more modern structure of today. (Courtesy of the Municipal Archives of the City of New York.)

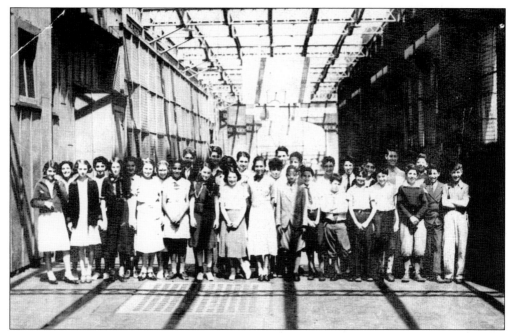

Early Brooklyn schools often placed the gymnasium in a grate-enclosed roof structure so students could enjoy fresh air and sunlight with their physical education classes. This 1939 image of the students at St. Claire McKelway Junior High School 178 in neighboring Brownsville emphasizes the exercise site's generous proportions.

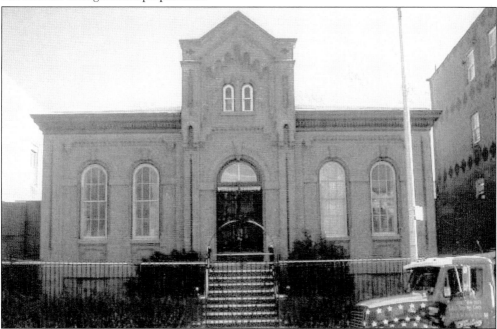

Public School 69 in nearby Williamsburgh is the only "colored" school building remaining in Brooklyn. Built in 1879–1881, it was once part of the African Free School founded by blacks in 1841. Brooklyn's board of education took over in 1855 and gave it the name Colored School No. 3, renamed Public School 69 in 1887.

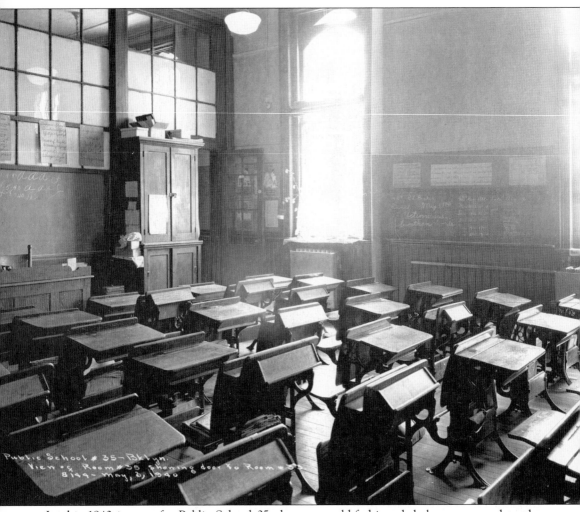

In this 1940 image of a Public School 35 classroom, old-fashioned desks are secured to the floor and sunlight floods through the huge windows. Cupboards, chalkboards, and paned room partitions capture the Victorian design of this long-vanished school, demolished in the 1950s. (Courtesy of the Municipal Archives of the City of New York.)

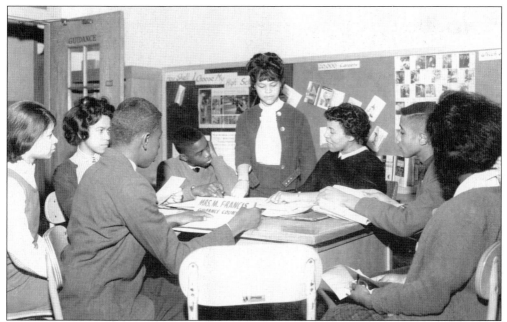

Mrs. M. Francis, guidance counselor at Public School 35, meets with graduating students faced with choosing their high school, which included the nearby Boys High School or Girls High School, neighboring Alexander Hamilton, Eastern District, Bushwick High, Franklin K. Lane, or other special schools like Brooklyn Technical or Brooklyn Automotive. (Courtesy of the Municipal Archives of the City of New York.)

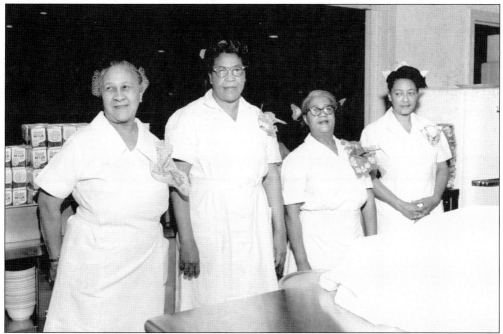

Students who attended Public School 44 in the 1950s may remember these immaculately dressed ladies from the cafeteria. Freshly starched dresses and carefully polished and scrubbed kitchen facilities were the standard of the day. (Courtesy of the Municipal Archives of the City of New York.)

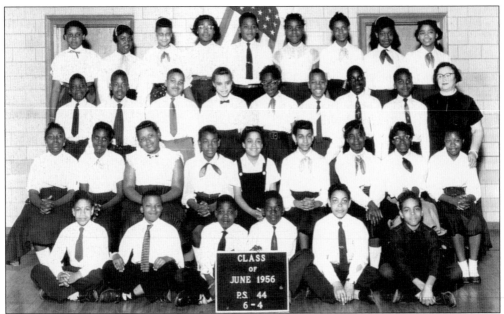

New York's educational system produced many bright stars, and this Public School 44 graduating class of 1956 includes future teachers, principals, administrators, medical doctors, and doctors of philosophy. Three of the brightest, Phylis Stubbs (top left), Rodney Guishard (top middle), and Linda Rhodes (center, in jumper), qualified for, and completed, a special program that accelerated seventh- to ninth-grade schooling into two years at Weeksville's Junior High School 210.

Linda Rhodes Jones attended Erasmus Hall High School, Brooklyn College, and Brooklyn's Polytechnic University and earned a master's degree in management. A successful career civil servant, she worked as a public school teacher and chief administrative officer for the New York City Department of Investigation and as director of administration at the Office of the Inspector General, New York City School Construction Authority.

Phylis Stubbs-Wynn, MD, is a noted pediatrician and former assistant commissioner of health for the Baltimore City Health Department. Stubbs-Wynn currently seeks to improve the health and developmental potential of infants and preschool-aged children as medical officer for the U.S. Department of Health and Human Services.

A graduate of Brooklyn Technical High School and Howard University, Rodney Guishard is a manager at the William J. Hughes Federal Aviation Administration Technical Center, Atlantic City International Airport in New Jersey, a federal lab engaged in aviation safety and security research. He currently leads the center's Office of Knowledge Management, is a private pilot with commercial ratings, and plans to participate in the upcoming cycling event, 2007 Bike New York.

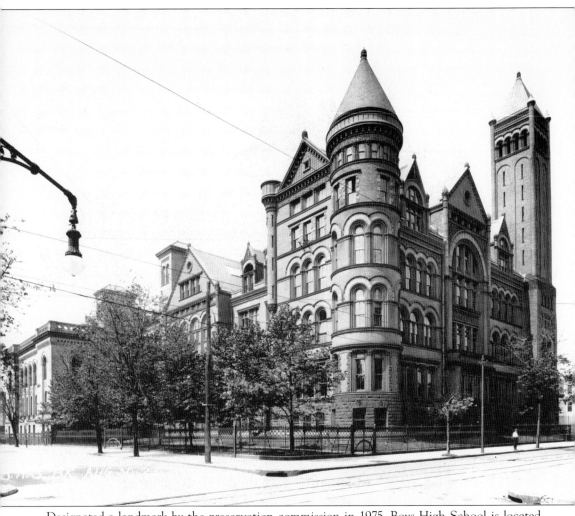

Designated a landmark by the preservation commission in 1975, Boys High School is located on Marcy and Putnam Avenues. The Romanesque Revival structure was a school of excellence for many decades, with alumni that include author Norman Mailer, composer Aaron Copeland, and basketball star Connie Hawkins. Today it is a designated alternative school offering adult education and remedial classes. (Courtesy of the Municipal Archives of the City of New York.)

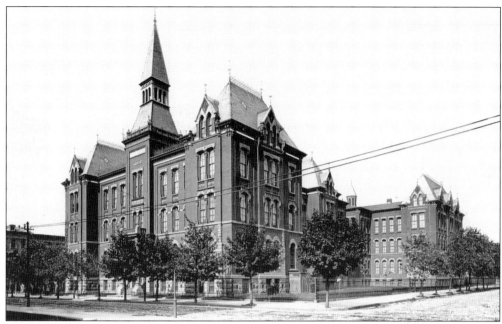

Girls High School, at Nostrand Avenue and Halsey Street, was designed by James W. Naughton and completed in 1885 as the new quarters for the Central Grammar School. The Gothic Revival structure graduated many noteworthy women, including entertainer Lena Horne and congresswoman and presidential candidate Shirley Chisholm. (Courtesy of the Municipal Archives of the City of New York.)

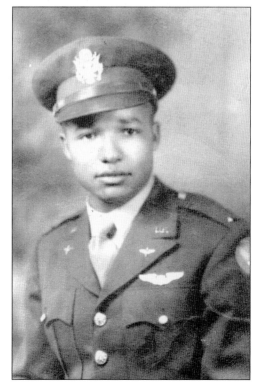

Boys High School graduate, Brooklyn Polytechnic Institute student, and Bedford-Stuyvesant resident George M. Rhodes Jr. qualified for the special Army Air Force Program at Tuskegee Institute. On August 26, 1944, 2nd Lt. George Rhodes was recognized by the *Brooklyn Amsterdam News* for serving with bravery during an air battle over France.

45

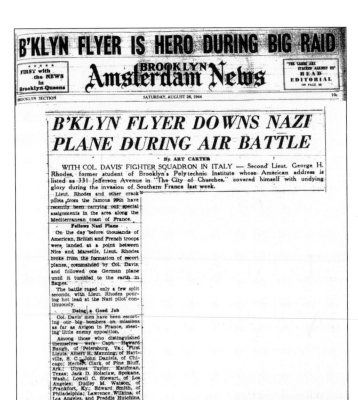

B'KLYN FLYER IS HERO DURING BIG RAID

FIRST with the NEWS in Brooklyn-Queens

BROOKLYN Amsterdam News

"THE 'CARDS' ARE STACKED AGAINST US" READ EDITORIAL ON PAGE 13

BROOKLYN SECTION SATURDAY, AUGUST 26, 1944 10c.

B'KLYN FLYER DOWNS NAZI PLANE DURING AIR BATTLE

By ART CARTER

WITH COL. DAVIS' FIGHTER SQUADRON IN ITALY — Second Lieut. George H. Rhodes, former student of Brooklyn's Polytechnic Institute whose American address is listed as 331 Jefferson Avenue in "The City of Churches," covered himself with undying glory during the invasion of Southern France last week.

Lieut. Rhodes and other crack pilots from the famous 99th have recently been carrying out special assignments in the area along the Mediterranean coast of France.

Follows Nazi Plane

On the day before thousands of American, British and French troops were landed at a point between Nice and Marseille, Lieut. Rhodes broke from the formation of escort planes, commanded by Col. Davis, and followed one German plane until it tumbled to the earth in flames.

The battle raged only a few split seconds, with Lieut. Rhodes pouring hot lead at the Nazi pilot continuously.

Being a Good Job

Col. Davis' men have been escorting our big bombers on missions as far as Avigon in France, meeting little enemy opposition.

Among those who distinguished themselves were Capt. Howard Baugh, of Petersburg, Va.; First Lieuts. Albert H. Manning, of Hartville, S. C.; John Daniels, of Chicago; Herbert Clark, of Pine Bluff, Ark.; Ulysses Taylor, Kaufman, Texas; Jack D. Holsclaw, Spokane, Wash.; Lowell C. Stewart, of Los Angeles; Dudley M. Watson, of Frankfort, Ky.; Edward Smith, of Philadelphia; Lawrence Wilkins, of Los Angeles, and Freddie Hutchins, of Donaldsonville, Ga.

The details of 2nd Lt. George Rhodes's air battle over France were shared with the 1944 readership of the African American newspaper the *New York Amsterdam News*. Headquartered in Manhattan, a Brooklyn branch office once operated on Fulton Street, producing Brooklyn editions of the paper. The *Amsterdam* is still publishing today.

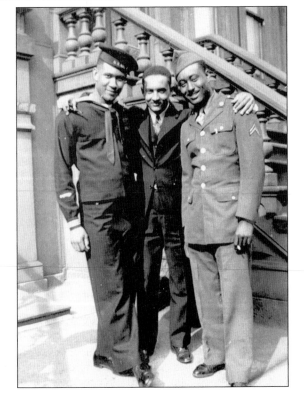

Tuskegee airman Lt. George Rhodes was but one of many Bedford-Stuyvesant residents who served with distinction during World War II. Two of the hundreds of men of color who also fulfilled their patriotic duty are Curtis (left), William, and James Bing (right). Here the brothers enjoy a moment of unity in front of their family's Jefferson Avenue home.

46

Four

INSTITUTIONS AND ORGANIZATIONS

Bedford's development of its many orphanages, libraries, financial institutions, hospitals, armories, political groups, and community organizations makes a common statement about the value that was placed on the importance of social stability.

Its municipal infrastructure was an early Bedford priority, with a safe and convenient water supply among its most important goals. In the 1660s, water was retrieved from wells, ponds, and springs. Brooklyn's landscape was convenient to the collection of water given the number of brooks and collect ponds (called *Klach Hooks*) that once abounded at that time.

In 1667, shortly after the British seized New York from the Dutch, the first public well was dug by the old Bowling Green fort located near Battery Park. The well used a pump, the first in the city's history, to bring the water from underground. Bedford also dug public wells to tap the fresh springs that flowed beneath the township, and in time wooden pumps were commonly set at intervals of approximately four blocks.

Eventually these became contaminated by the filth from the streets, outhouse vaults, and cesspools that saturated the soil and was later carried by rainwater into the wells. This contamination created diarrheal diseases including cholera, cholera morbus, and dysentery, all traceable to impure well water.

In working with the common council, plans were made in 1884 to close 296 Brooklyn pumps, to be replaced by water from both the Ridgewood and Prospect Park Reservoirs. This was decided following the death of two children, six and eight years old, who drank contaminated water from a pump situated on Dekalb Avenue between Throop and Tompkins Avenues. Other contaminated pumps in Bedford-Stuyvesant included Putnam Avenue between Franklin and Classon Avenues, Tompkins Avenue corner of Gates Avenue, Greene Avenue between Reid and Patchen Avenues, the corner Sumner and Monroe Avenues, and Stuyvesant and Gates Avenues.

On a more positive note, in the 1890s, Andrew Carnegie contributed $1.6 million to create a free public library, with the very first branch opened on December 20, 1897, in Bedford in the old Public School 3 building. Known as the Bedford Branch, it is still in operation on Franklin and Jefferson Avenues, across the street from the modern Public School 3. The nearby Tompkins Park Library soon followed with an opening on June 6, 1899.

Local orphanages included the Church Charity Foundation at Albany Avenue and Herkimer Street, the Hebrew Orphanage at Stuyvesant and MacDonough Avenues in 1878, and the Protestant Orphan Asylum at Atlantic and Kingston Avenues. The Howard Colored Orphanage at Dean Street and Troy Avenue was created in the 1860s with the support of the many local and downtown black churches that still exist today.

In 1832, the African American Weeksville community was begun with the purchase of 30 acres of woodland by a local man of color, New York City chimney sweep William C. Thomas. Soon after, James Weeks and William Thompson bought land from Leffert Lefferts, which they also offered for sale to blacks who wished to buy affordable lots for homes. The community produced its own local newspaper, had its own school, ran its own orphanage, and established the African Civilization Society in 1865 to support, aid, and educate freedmen in southern states. This location, once considered part of Bedford-Stuyvesant, is today redistricted as Crown Heights North.

The local Roman Catholic St. Joseph's Home for Females was at Willoughby and Sumner Avenues, and the St. John's Home for Males at St. Marks and Albany Avenues. The Baptist Home at Greene and Throop Avenues was run by the Lutheran Church.

Hospitals like the Central Throat were on Broadway and Howard Avenue, with the Home for Consumptives at Kingston Avenue and Butler Street, St. John Hospital at Atlantic and Albany Avenues, St. Mary Female Hospital at Dean Street, and the Swedish Hospital at 1080 Pacific Street.

A famous political organization was the Brooklyn Union League Club of New York to which nearly all prominent Republicans belonged. In 1894, the Union League was noted for its admittance of women to more privileges than most organizations of the day. Started in 1887 with a membership of less than 20, it grew to over 800 by 1888. It incorporated with the specific goals "to advance the cause of good government by awakening a political interest in its citizens, overcome existing indifference in the discharge of political duties, and performing such other work as may best conserve to the interest of the Republican party," noted at that time as the party of the Union army and Abraham Lincoln.

In the winter of 1890–1891, the club moved into its new house on Bedford Avenue and Dean Street, described as "one of the best of the great residence sections of the city." An outstanding landmark of Bedford-Stuyvesant, it is now a senior citizen's center. The equestrian statue of Ulysses S. Grant in front of this building, donated by the Union League in 1896, remains a prominent fixture as well.

Secret societies were in great number in Bedford, and the Masons are well represented in this regard. Included is the Most Worshipful Enoch Grand Lodge at Jefferson and Nostrand Avenues, once the Reformed Episcopal Church of the Reconciliation and lodge headquarters for the past 57 years.

The Ancient Arabic Order of Nobles of the Mystic Shrine once occupied the spectacular Kismet Temple on Herkimer Street near Nostrand Avenue. This onion-domed structure still stands today and serves as the home of Friendship Baptist Church.

Bedford banks included the Brevoort Savings Bank, founded by local son Henry Lefferts Brevoort at 1198 Nostrand Avenue and, in 1932, at 1281 Fulton Street; Kings County Bank at Broadway and Bedford Avenue; the Brooklyn Trust Company at Herkimer Street; and the Eastern District bank at Broadway and Gates Avenue.

In the old days, there were no sewers, waterlines, or indoor plumbing. Water was obtained from wooden pumps at community wells placed every three to four blocks. Pictured here is a relic of the pump days once situated at Fulton Street and Grand Avenue.

The Graham Institution, located on Washington and DeKalb Avenues, provided care for aged females in the early 19th century. On close inspection of the structure, one can see water being pumped from a public well stationed in front of the institute.

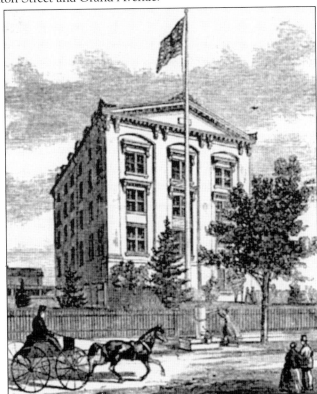

Water was brought from the Ridgewood reservoir to Bedford on December 14, 1858. Three days later, on December 17, a fire was quickly extinguished using the newly installed water lines. Here in 1898, a boy on Caton Avenue in Flatbush works the pump handle beside a hotel that also "sheds" the horses of their guests. (Courtesy of the New York Historical Society.)

To help children orphaned and half-orphaned by the Civil War, the Howard Colored Orphan Asylum was founded in 1866 by Sarah A. Tillman. Local churches that aided its growth included Mount Lebanon and Concord Baptist churches, Siloam Presbyterian, and the Bridge Street AME Church. Located in Weeksville on Dean Street and Troy Avenue, and later Kings Park, it closed tragically in 1918 due to lack of funds.

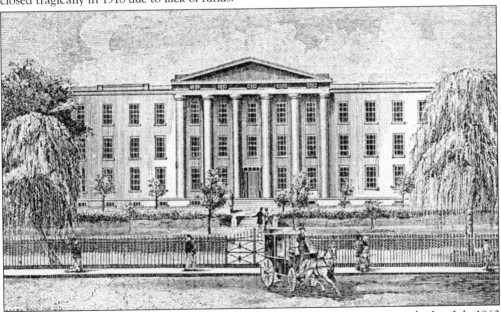

When the Colored Orphan Asylum on 42nd Street and Fifth Avenue was torched in July 1863 by rioters protesting the Civil War draft, many of Manhattan's homeless children and local black residents sought safety in Brooklyn's Weeksville. The black population increased following this migration, stretching the resources of the Howard orphanage.

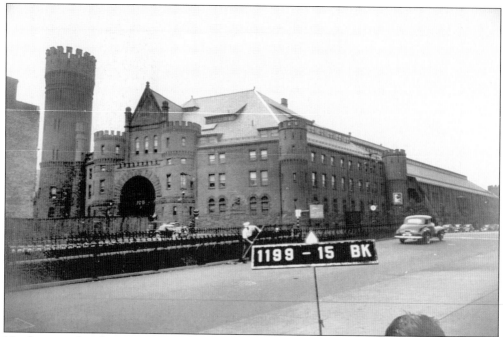

Headquartered at the cross streets of Bedford and Atlantic Avenues, the 23rd Regiment Armory helped to keep civil order in the heart of Bedford and beyond. Its 136-foot-high castlelike structure, constructed in the medieval style of Norman architecture, housed the National Guard regiment that saw service in Pennsylvania and Virginia and served as cavalry from 1867 to 1869. (Courtesy of the Municipal Archives of the City of New York.)

The Hotel Chatelaine once occupied the Bedford Avenue site of the Swedish Hospital in Grant Square. Today the building serves as a newly renovated, multiunit apartment complex. The hotel's copper-lettered wording (top left corner) still remains on the building.

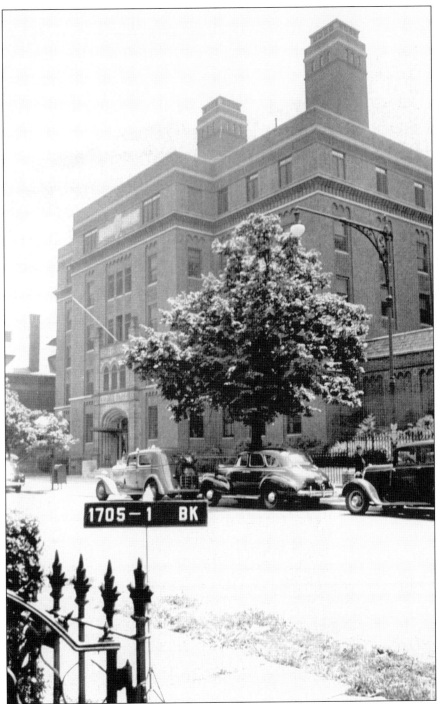

The Episcopal Church Charity Foundation founded St. John's Hospital in February 1851 "for indigent persons and for the welfare of orphans, half orphans and other destitute children." Originally located on Atlantic and Albany Avenues, the new hospital constructed around the corner at 480 Herkimer Street and Albany Avenue was completed in 1927. (Courtesy of the Municipal Archives of the City of New York.)

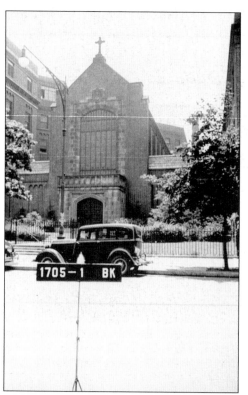

On October 12, 1926, the church cornerstone adjoining St. John's Hospital, named the Walter Gibb Chapel, was financed by Florence Gibb in memory of her husband, who died in 1918. During the ceremony, Bishop Ernest M. Stires of the Episcopal Diocese of Long Island remembered Walter Gibb as "a Christian gentleman of high repute in our community and a churchman whose talents were of much value to our diocese." (Courtesy of the Municipal Archives of the City of New York.)

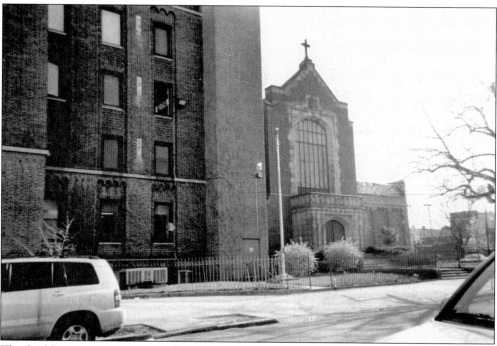

The building once attached to the Walter Gibb Chapel in 1926 has been removed, and a large parking lot has replaced it. The remaining medical facility, renamed Interfaith Hospital, currently services patients from its Atlantic Avenue address.

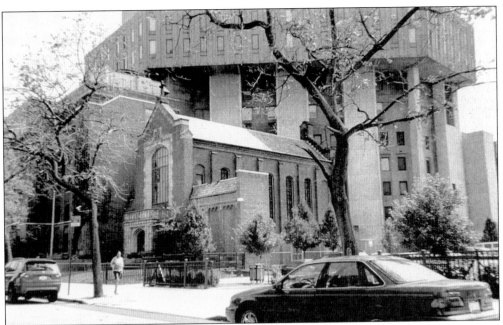

This westerly view shows that the Gibb chapel now sits in the shadow of a new multistory wing of Interfaith Hospital, a branch of Episcopal Health Services. The building addition to the former St. John's Hospital at Herkimer Street and Albany Avenue was completed in 2002.

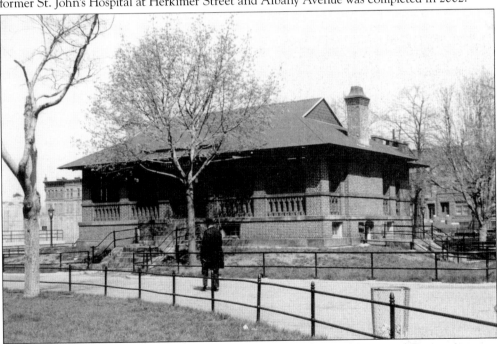

The Grecian-styled Tompkins Park library at Tompkins, Lafayette, Marcy, and Greene Avenues, opened on June 6, 1899. In the center of a vernal park designed by the famed team of Frederick Law Olmstead and Calvert Vaux, also the landscaper for both Prospect and Central Parks, the Brooklyn library was one of the first of 21 financed by Andrew Carnegie. (Courtesy of the Brooklyn Public Library.)

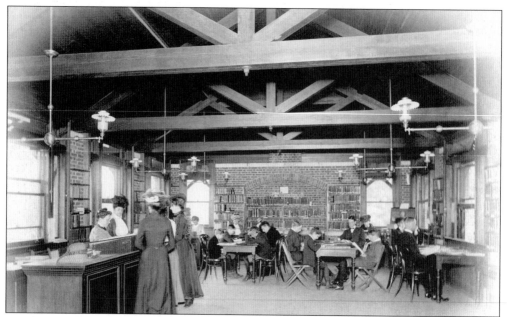

Long-skirted library patrons are serviced by a pair of librarians, while young men in knickers seated nearby focus on their books. The vaulted ceiling provided a spacious element for the small-scaled Tompkins Park library. The library was destroyed by fire on March 15, 1969. (Courtesy of the Brooklyn Public Library.)

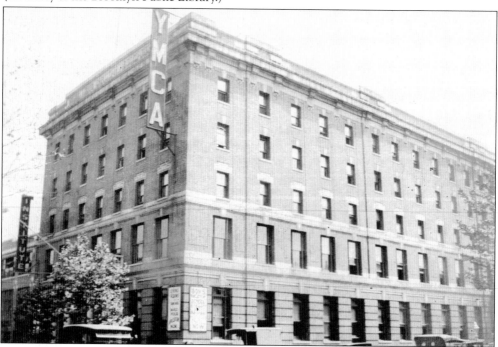

In the 1920s, a civic group called the Gates Avenue Association fought to prevent blacks from using this YMCA facility and moving into the neighborhood. Having overcome this conflict, the Gates Avenue YMCA remains at Bedford Avenue, providing needed services after more than 87 years in the location.

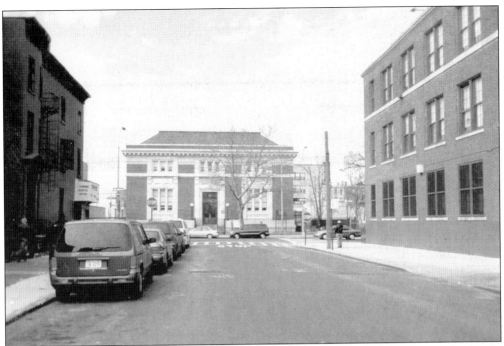

The Bedford library on Franklin and Jefferson Avenues has occupied this site since the 1890s, near the heart of what was once Bedford Corners. After a renovation closure of several years, library patrons today enjoy a newly restored interior and a beautifully refurbished exterior.

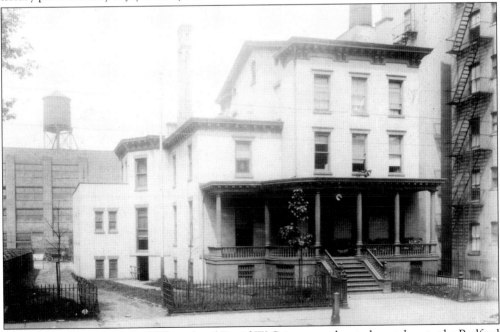

The home of American Civil War colonel David W. Stires, once located next door to the Bedford Library on Franklin Avenue and Hancock Street, became the Unity Club in the early 1900s. Listed with a membership of 165 in the American Jewish Year Book, the organization bought the prestigious Union League Club on Grant Square in 1914 and sold nearly 30 years later in 1943.

A vacant lot next to the Bedford Library marks the spot where Unity Club used to hold its meetings. It is believed that an archaeological dig might unearth Revolutionary War artifacts since active construction was largely limited to the 1890s and early 1900s, leaving much of the Bedford-Stuyvesant substrata undisturbed.

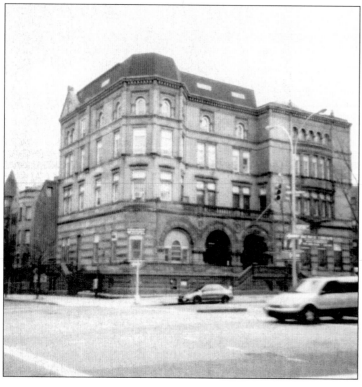

The magnificent Romanesque Union League Club, shown today without its once-impressive corner steeple, was built to serve the local Republican party members of Bedford. Designed by P. J. Lauritzen and constructed in 1890, it was purchased by the Jewish Unity Club in 1946 prior to moving from the club's Franklin Avenue at Hancock Street address. Today the building houses the Grant Square Senior Citizens' Center.

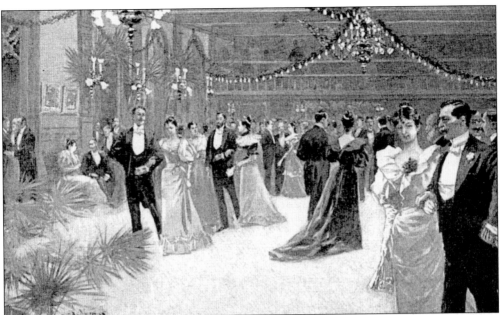

Described as a neighborhood club, its membership numbered over 800 when this Annual Ladies Reception was held in January 1894. Over 1,000 tickets were sold to finance the club goals of "awakening a political interest in [local] citizens and overcoming existing indifference in the discharge of political duties."

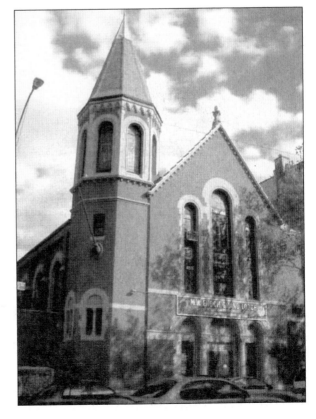

The Most Worshipful Enoch Grand Lodge has maintained headquarters on the corner of Jefferson and Nostrand Avenues since the 1950s. Formerly the home of the Reformed Episcopal Church of the Reconciliation, this stained-glass, brick, and terra-cotta Masonic temple was constructed in 1890 by architects Heins and La Farge. (Courtesy of Tom Fletcher.)

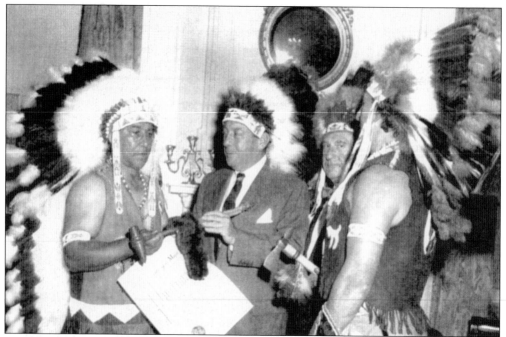

Former New York City mayor Robert H. Wagner (1954–1965) takes pleasure in presenting a proclamation to Jules "One Arrow" Haywood recognizing September 29 as American Indian Day. One Arrow was head and leader of United American Indians, an organization committed to securing Native American rights, recognition, and job opportunities. (Courtesy of Rachael O'Connor.)

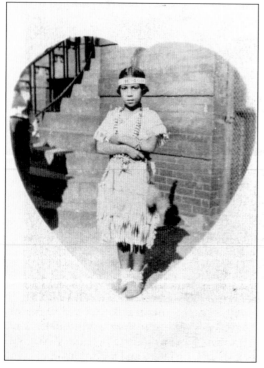

Rachael Sequoya, also known as Red Feather, dressed here in Native American regalia, regularly attended powwows led by her father, One Arrow. For years, One Arrow ran a Native American shop located on Myrtle Avenue and would lead educational classes and authentic Native American dances at various venues, including the Brooklyn Children's Museum. (Courtesy of Rachael O'Connor.)

One of the oldest African American women's lodges in the country, the United Order of Tents Lodge No. 3 has owned this house at 87 MacDonough Street since August 1945. The organization was founded in Virginia in 1867 by two slave women, Annetta M. Lane of Norfolk and Harriet R. Taylor Hampton, and abolitionists Joshua R. Giddings and Joliffe Union.

The stillness of winter enhances the false impression of a quiet rural setting from this rear view of the United Order of Tents Lodge. Tranquil on its four-lot setting, it remains one of few pre–Civil War structures remaining in Bedford-Stuyvesant. Over the years, the building has functioned as Peoples Institutional Methodist Community Church in the 1940s and as St. Mark's Sanatorium from 1921 to 1924.

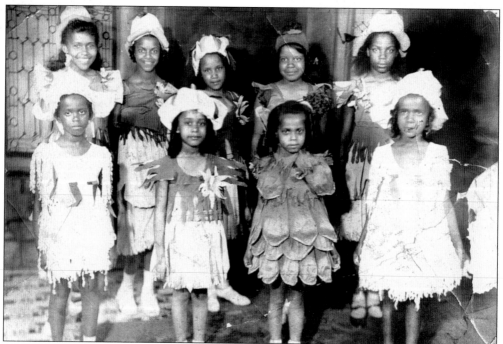

Daughters of the women's United Order of Tents lodge enjoy an annual floral festivity as they don handcrafted designs created by their mothers. The girls, in their crepe paper dresses, form a sweet human bouquet.

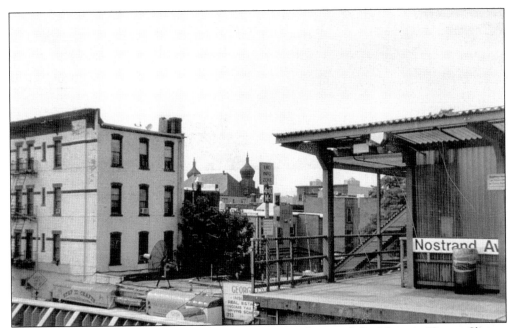

The onion domes of Friendship Baptist Church, once home of the Masonic Kismet Shrine, are visible from the Nostrand Avenue stop on the elevated Long Island Rail Road in Bedford-Stuyvesant. On more than one occasion during the early 1900s, this structure also functioned as the venue for Howard Colored Orphanage fund-raising events.

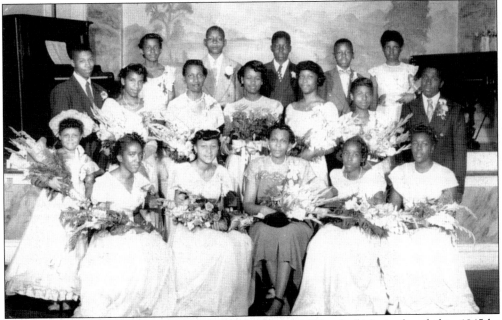

Neighborhood cultural institutions included the Putnam School of Music, founded in 1945 by Beryl Stubbs who studied at the Julliard School of Music. Annual brownstone piano recitals were given at her Putnam Avenue address and in nearby St. Augustine and Siloam Presbyterian Churches. Here Beryl Stubbs and her students radiate quiet dignity following a 1949 concert. (Courtesy of Phylis Stubbs-Wynn.)

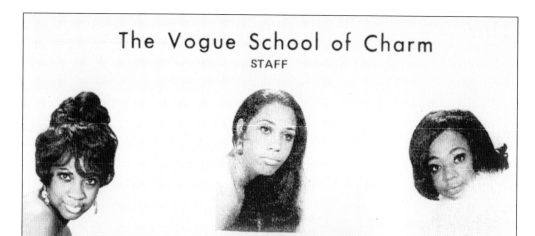

The Vogue School of Charm
STAFF

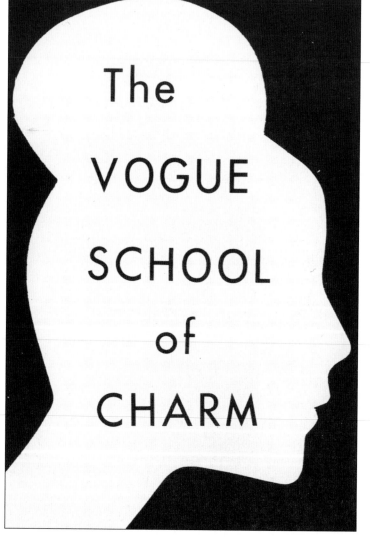

The VOGUE SCHOOL of CHARM

In the 1950s and 1960s, the Vogue School of Charm performed a critical service for Bedford-Stuyvesant women by bringing style, grace, and beauty to many who had been told it was beyond their reach. Founders Eddye Elijah (left) and sister, Arlene Chalmers (right), along with their staff of 12, including modeling instructor Ruth Hunt (middle), instilled the school's students with the self-confidence needed to achieve the goals and careers of local women of color. (Courtesy of Ruth Hunt.)

Five

INTERMENTS

The earliest records of interment can be found in downtown Brooklyn, with the first public burial ground designated in 1626 by Dutch governor Peter Stuyvesant at today's Fulton Street and Gallatin Place. Other early cemetery locations include St. Ann's Church burying ground on the east side of Fulton Street, opposite the corner of Clinton Avenue; the First Reformed Dutch Church at Fulton and Hoyt Streets; and the Wallabout Cemetery at Canton and Park Avenues, established in 1824 in the vicinity of Fort Greene, once belonging to Leffert Lefferts.

The Breukelen graveyard was established along today's Fulton Street, and a blockhouse was built nearby to protect the settlers against attacking Native Americans. Located on Lawrence and Bridge Streets, the churchyard was about a half acre of ground and continued to be used for burial purposes until 1848. In 1833, the Schenck family plot was located nearby at Boerum Place between Schermerhorn Street and Livingston Street.

Located three-and-one-half miles from these downtown sites, early Bedford's local farms, churchyards, and family plots commonly received the remains of their 17th- and 18th-century departed. The town's community burial ground was once located on Halsey Street on the east side of today's Bedford Avenue. Nearby was the Lefferts family burial place located in a grove in the back of Rem Lefferts's house at Cripplebush Road and Halsey Street. The march of improvement forced removal of bodies to Greenwood Cemetery in the 1870s, and in 1893, a tombstone was found propping up a clothesline post that read, "In Memory of / Jacobus Lefferts who departed this life on 9 October 1805 / Aged 48 years, 10 months, 4 days."

The DeBevoise farmhouse, built by Michael Vandervoort in 1776 and torn down in 1868, once held the DeBevoise private burying site at today's Putnam and Jefferson Avenues on the west side of Bedford Avenue.

A recent inspection of a 1766 map from Ratzer's survey shows an African American burying ground slightly south of Bedford Corners. Located on Bergen Street and the old Clove Road, this graveyard was exclusively for people of color as dictated by the local laws of discrimination.

In 1849, the City of Brooklyn passed an ordinance prohibiting further burials of any person (regardless of race) within city limits. Shortly following, the bodies at the former Wallabout Cemetery were exhumed to Cedar Dell in Greenwood Cemetery, and the Wallabout Market was established. With the occurrence of World War II, the market also closed to make room for Brooklyn Navy Yard expansion.

In 1850, Bedford Avenue was constructed to replace the Cripplebush Road, which ran north from Bedford Corner to DeKalb Avenue. Cripplebush Road was discontinued when the new street was cut through the old farms, but some detached portions still remained. There was once

a tract between the Cripplebush Road and the new avenue that was a burying ground for the remains of African American slaves from the old days.

Union Cemetery, however, was rare in that it did not discriminate, providing burials regardless of race or religion. Located on the edge of Bedford-Stuyvesant, this 10-acre site was at Putnam Avenue and Palmetto Street, flanked by Knickerbocker and Irving Avenues. Run by the First Protestant Methodist Church, in June 1851, it was ordered to move the remains of 7,000 people to the Cedar Grove Cemetery in Queens. A portion of Union's former site is now a playground.

It was the difficulty in finding burial space that led a group of black men in 1851 to seek permission from Brooklyn's common council to purchase a 29.5-acre plot in outlying Weeksville for the purposes of burying people of color. Upon receiving council approval, owners Alexander Duncan, Robert Williams, and Charles Lewis, described as "respectable colored men," converted 12 acres of the designated land into a burial ground.

Named the Citizen's Union Cemetery, it sat upon extremely hilly ground with large boulders, 50-foot hollows, and stone outcroppings. Located between today's Sterling Place, Eastern Parkway, and Buffalo and Rochester Avenues, it was enclosed by a wooden fence, with a small one-story frame building near the wooden gate on Butler (Sterling) Street and a vault underneath for the temporary reception of the dead. The entry gate was on the northwest corner of Sterling Place and Buffalo Avenue.

The cemetery was unique in that it offered free burials to the poor, charging only to open and close the grave. This caused immediate financial hardships. Given the poverty of the clientele, investors received a poor return, which caused many stockholders to sell their shares. The cemetery reorganized in 1854 under the Mount Pleasant Cemetery Association.

It continued at a loss until April 28, 1870, when the cemetery was ordered to be closed and the bodies removed due to the scheduled construction of Eastern Parkway, also known as "the Boulevard." The court stipulated the purchase of a plot to receive the exhumed bodies in Cypress Hills Cemetery in Queens County, and many in unmarked graves were placed in a common trench at the new site. Poor bookkeeping at times resulted in bodies being unexpectedly discovered as roadway construction began.

At the time of closing, the lands belonging to the association were conveyed to Margaret Barnwell, Alexander Duncan, Robert J. Williams, Thomas Jackson, George H. Dixon, William F. Dixon, George E. Baker, William L. Nicholas, and Paul Pontau.

Today a large obelisk at Cypress Hills marks the burial ground for the bodies removed from the Union/Mount Pleasant Cemetery. This memorial was installed by members of the Fleet Street AME Zion Church, a black church once located in downtown Brooklyn, as well as other African American churches, the names of which are indecipherable due to the erosion of the sandstone marker.

One of the most noteworthy and well-marked graves within the Mount Pleasant site at Cypress Hills is that of the Reverend William T. Dixon, a widely known preacher and pastor of Concord Baptist Church of Christ for 46 years who died in 1909, 30 years after the closure of Mount Pleasant. He was said to have officiated at more funerals and marriages than any other clergyman in the city and lived at 106 Adelphi Street.

With regard to the exhumed graves, plans are being made to decipher the eroded monument wording and refurbish the obelisk. Steps will also be taken to recognize the appropriate grounds along today's Buffalo Avenue at the site of the former Mount Pleasant Cemetery, a burial ground for people of color between the years of 1851 and 1870.

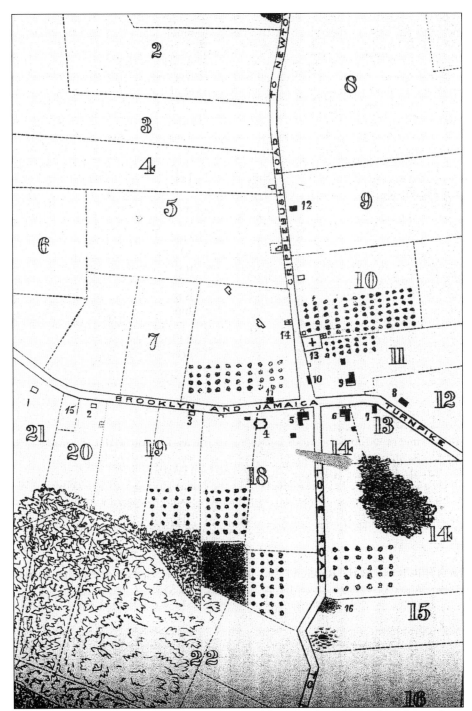

A Bedford Corners map in Henry Stiles's A *History of the City of Brooklyn* is based upon Ratzer's survey of 1766–1767 showing the farm lines, roads, and houses that existed at that time. This resource confirms (in small numerals) the community burial sites of Bedford Village (13), the Remsen family burial ground (left of large number 15), and the Negro Burial Ground (16) at Bergen Street and the Clove Road.

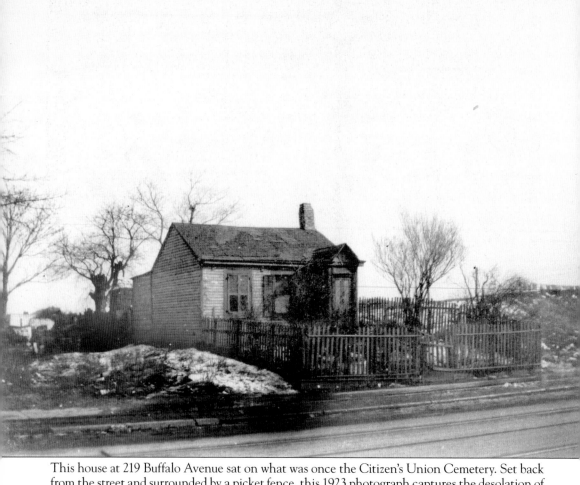

This house at 219 Buffalo Avenue sat on what was once the Citizen's Union Cemetery. Set back from the street and surrounded by a picket fence, this 1923 photograph captures the desolation of the former burial ground as it sat undeveloped for decades due to litigation problems. (Courtesy of the New York Historical Society.)

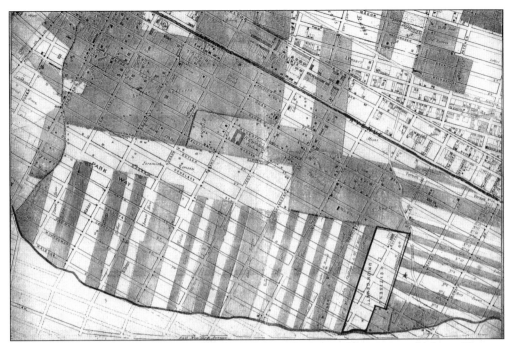

Founded in 1853 by men of color, the Citizens Union Cemetery, later renamed Mount Pleasant Cemetery, is detailed in the above map and shows the well-traveled Hunterfly Road, once an old Native American trail. The 12-acre cemetery was sold and bodies removed to Cypress Hills cemetery in the 1870s to make way for the construction of Eastern Parkway.

This modern-day image of Bergen Street between Nostrand and Rogers Avenues approximates the location of the Negro Burial Ground from the Ratzer survey map. A significant gated gap in the residential buildings, now a parking space, approximates the positioning and location of the forgotten Clove Road that once ran north to south from the old Dutch township of Flatbush.

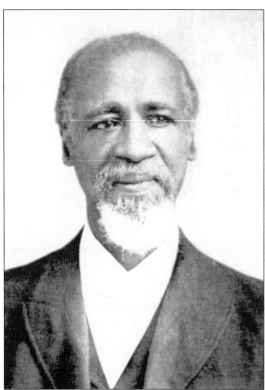

The Baltimore-born Rev. William T. Dixon led Concord Baptist church from 1863 to 1909, increasing membership by more than 1,800 persons at the Duffield Street location. At his death in 1909, it was said he had officiated at more funerals and marriages than any other clergyman in the city. He is buried at the Mount Pleasant plot in Cypress Hills Cemetery.

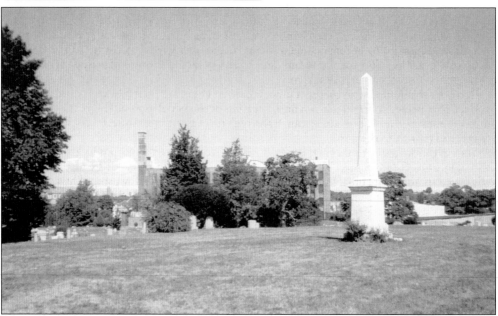

In 1870, the exhumed bodies of the former Citizens Union Cemetery were removed to this site in a quiet corner of Cypress Hill Cemetery. An obelisk, erected by a number of African American churches, including Fleet Street AME Zion, marks their final resting place. The elements of wind and rain have largely obliterated the monument's inscription, making it almost entirely indecipherable. (Courtesy of Jennifer Scott, Weeksville Heritage Center.)

Six

TRANSPORTATION

The successful growth and eventual prosperity of Bedford Township can be largely traced to its strategic location at the crossroads of three major thoroughfares. Even the earliest travelers wishing to reach any northern, southern, or eastern destination would, in most cases, have to pass through Bedford Corners. By heading east along the Brooklyn and Jamaica Turnpike (also known as the Kings Highway, and later Fulton Street), a fork in the road at Bedford connected with the old Native American trails of Cripplebush Road, leading north to Newtown, and the Clove Road, which led south to Flatbush.

It is significant that an inn was the first public building erected in Bedford Corners. Built by Thomas Lambert in 1668, "to accommodate travelers," this endeavor was the first of many that allowed Bedford to become home to many of Brooklyn's most successful residents. These included the Lefferts, Remsen, Boerum, and Brevoort families whose names are synonymous with Bedford-Stuyvesant and Brooklyn.

These early families owned acres of land, created a variety of orchards, and raised bushels of produce that helped to feed the town and a portion of the population in Manhattan. The early infrastructure of the Native American trails and their further expansion also brought great wealth and growth to the area.

One of the first steps taken to improve the delivery of dairy and produce was the 1702 development of Fulton Street. This superior road, then called the Jamaica Road, remained the only paved thoroughfare until 1840, providing a direct route to Ferry Township. This community was named for the first reliable means to cross the treacherous currents of the Hudson to reach New York, the site of the former Native American village Maeferckkaakwick.

In the earliest days, travel between Manhattan and Long Island was achieved by private boats owned by Long Island farmers. In the 1640s, the rowboat ferry was established with Cornelius Dircksen, one of the earliest known ferrymen. Fifteen years later, ferrymen Egbert Van Borsum built the first ferry house in 1656. Constructed of Holland brick, it also doubled as a public tavern.

By 1717, two ferries were provided to run from Long Island landing to the New York slips, the *Nassau* ferry carrying cattle, goods, and passengers on one, and the *New York* ferry carrying only goods and passengers. In 1795, the New Ferry was established, and in 1803, Old Ferry and the New Ferry were the only two running. The Old Ferry operated two kinds of boats: the barges, rowed by four men each and holding 8 or 10 persons, and the sailboats, with deep bottoms. These had no regular steersman, and the first passenger to arrive took the helm. Horses and wagons were in the bottom of the sailboat, exposed to all kinds of weather, like the passengers.

Eventually horse boats provided transport by driving four horses around a pole, connected to a gearshift that rotated the paddle wheels.

With the Old Ferry lease expiring in 1813, Robert Fulton and William Cutting obtained a franchise for a ferry to begin to run in 1814 from Old Ferry Street, Brooklyn, to Fly Market and Burling Slips, New York. The first steamboat was the *Nassau*, also called *Sall*, which began running on May 10, 1814, and carried as many as 550 passengers, and a few wagons, on one trip. Other boats included the *Long Island Star* and the *Decatur* (a horse boat converted into a steamboat). With Robert Fulton's death on February 23, 1815, partner William Cutting continued to improve the quality of water transport between Long Island and New York.

At this same time, the quality of land transportation also improved. In 1832, the Brooklyn and Jamaica Rail Road Company incorporated and received a 50-year charter to build a steam railroad to Jamaica. Having become a city in 1834, Brooklyn wanted a highway from Ferry to Bedford. In 1837, the company was authorized to select Bedford's Atlantic Avenue (being a straight line continuation of Atlantic Street in the Brooklyn City) as the terminus of the railroad, which connected South Ferry with New York City. This resulted in Bedford-Stuyvesant, even today, being just one stop away from the Long Island Rail Road terminal in downtown Brooklyn.

Stages were running to Flatbush as early as 1830. The doors were on the side, with straw packed on the floor to provide some measure of warmth for the passengers and small whale-oil lamps to provide light. Omnibuses were introduced in 1834, a new kind of stagecoach having rear doors. It did not run over special routes, but destinations were determined by the passengers, a predecessor of the modern taxi.

There soon followed many stage lines, most starting at the 26 Fulton Street old stone tavern. By 1854, horsecars (a 40-passenger car on iron rails) began to run from Fulton Ferry on Fulton Avenue, Myrtle Avenue, and Flushing Avenue, streets all located in Bedford-Stuyvesant. In time, horse-drawn railcars were replaced by trolley service; and in 1885, the Fulton Street elevated train provided rapid transit through Brooklyn, down to Ferry, and eventually across the Brooklyn Bridge, which was opened in 1883.

This convenient connection eventually led to the 1898 unification of Brooklyn with Manhattan. By becoming one of the five boroughs that comprised New York City, many Brooklynites felt this meant the end of Brooklyn's separate identity, forcing it to become a satellite of Manhattan.

Many agree, however, that the 1936 opening of the Fulton Street A-train most changed Bedford-Stuyvesant. The convenience of this subway line allowed travelers to reach many parts of New York in record time and placed 125th Street in Harlem a mere 30 minutes away from the heart of Bedford-Stuyvesant. It opened the door for greater access to available job opportunities and unified two formerly independent African American communities.

Jazz artists and composers Duke Ellington and Billy Strayhorn made this point musically with the 1937 release of the popular song "Take the A-Train." Their lyrics sum it up beautifully: "You must take the A-train / To go to Sugar Hill way up in Harlem / If you miss the A-train / You'll find you missed the quickest way to Harlem."

The period of transition was accelerating again in the Bedford community, and in looking back, it was evident that transportation played its own role in transforming a township that had remained in flux since shaking off the final remnants of its sleepy agricultural pace in the 1890s.

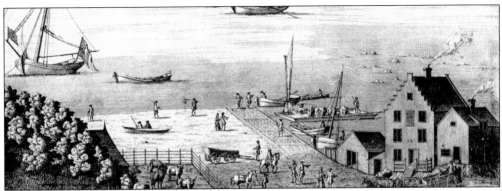

Water transport was needed to deliver the meat, dairy, and agricultural goods produced by Long Island's farming communities like Flatbush and Bedford Corners to the Manhattan market. Barges served this purpose from the earliest days of Brooklyn's settlement until ferry transportation came into being. Here cattle and passengers traverse the Hudson River to reach their New York destination.

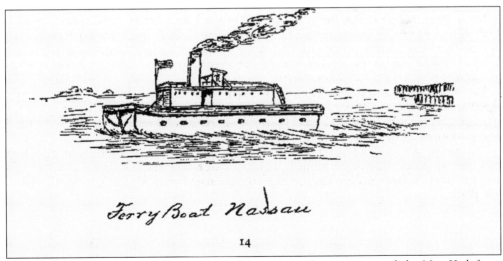

Ferry Boat Nassau

14

In 1717, the *Nassau* ferry, which carried cattle, goods, and passengers, and the *New York* ferry, carrying only goods and passengers, provided transport between New York and Brooklyn. By 1803, passenger barges and sailboats rowed by the first male passengers to arrive at the dock were replaced by horse-driven paddleboats.

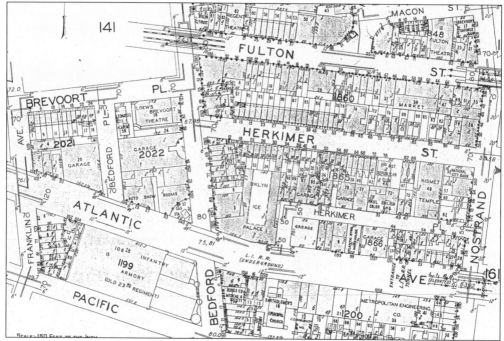

This image of the six-block street grid from the 1920s captures the close proximity of seven local institutions once found at the center of Bedford, including, from left to right and south to north, the 106th Infantry Armory and St. Bartholomew's Episcopal Church on Pacific Street and Bedford Avenue; St. Leonard's Academy (once the Lefferts/Brevoort homestead) abutting the Loew's Brevoort theater on Brevoort Place; the Brooklyn Ice Palace and Kismet Temple off Herkimer Street; and the Brevoort Savings Bank once on the corner of Macon Street and later moved to the renovated Fulton Theater around the corner.

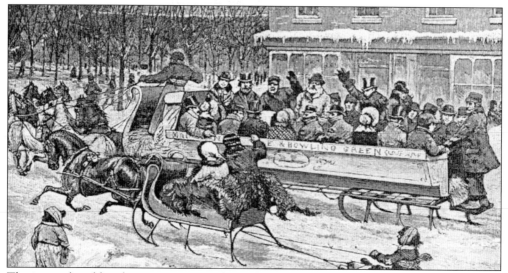

The intensely cold and snowy winters in the 17th, 18th, and 19th centuries often froze the New York waterways. Undaunted, residents often walked the frozen river between the Manhattan and Long Island shores. They also traveled by sleighs, both large and small, like this 1860 example shown speeding along Manhattan's Broadway.

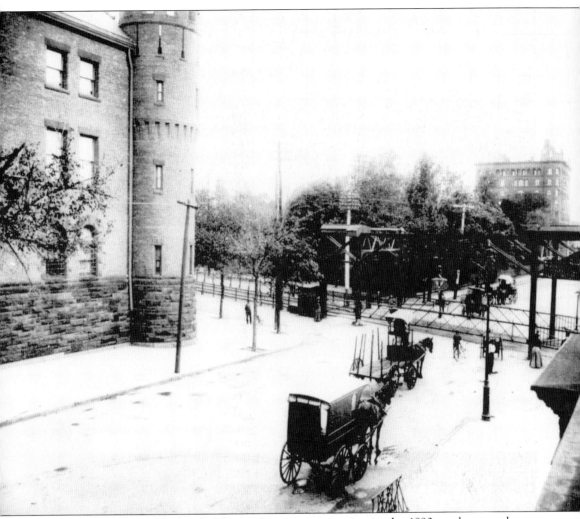

A gate blocks the Bedford and Atlantic Avenues intersection in the 1890s, as horse and man wait near the 23rd Armory for the Long Island Rail Road to pass. A tunnel will later eliminate this inconvenience. The prestigious Brevoort Hotel (also known as the Haliday Building) marks the busy location of Bedford Avenue and Fulton Street, a short walk from the Lefferts and Brevoort family homestead at Brevoort Place hidden by a stand of trees. (Courtesy of the Brooklyn Historical Society.)

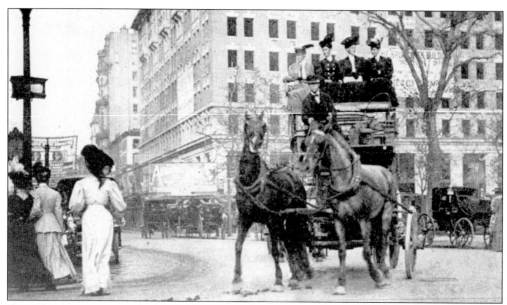

Four Victorian women sit atop a horse-drawn omnibus as it rounds the corner at Union Square in Manhattan. In 1850s Brooklyn, Montgomery Queen provided four-horse service and owned the stage route from the downtown ferry to Bedford. It then traveled as far as the African American communities of Weeksville and neighboring Crow Hill. (Courtesy of the New York Transit Museum.)

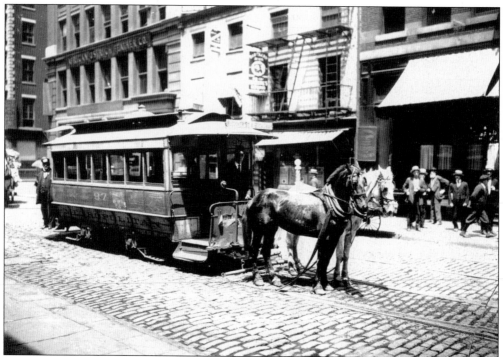

Before trolleys ran by electricity, they were drawn on rails set in cobblestone roads by horses. This model shown in Manhattan is very much like those used on the streets of Brooklyn. (Courtesy of the New York Transit Museum.)

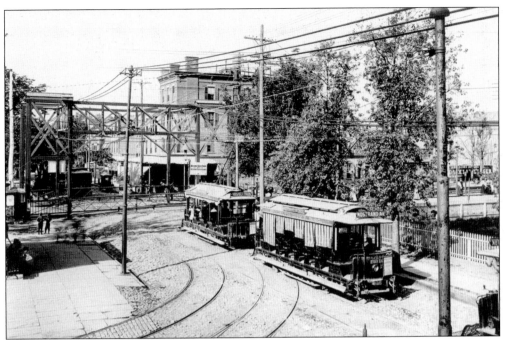

The drawn striped panels of this Nostrand Avenue trolley shield the passengers from heat and sun as they wait for a Long Island train to travel on grade along Atlantic Avenue. Today the tracks are elevated at this Nostrand Avenue location, still one of the busiest and most congested intersections in the neighborhood. (Courtesy of the Brooklyn Historical Society.)

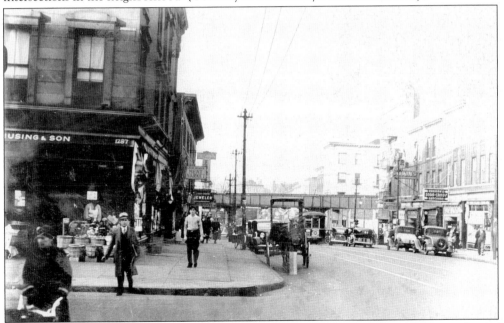

Taken at one of the busiest intersections in Bedford-Stuyvesant, this 1920s snapshot of Nostrand and Atlantic Avenues captures the changes that were wrought since simple trolleys and horse-drawn wagons traversed the roadways. In coming decades, greater car ownership and larger populations would make the streets even busier. (Courtesy of Brian Merlis.)

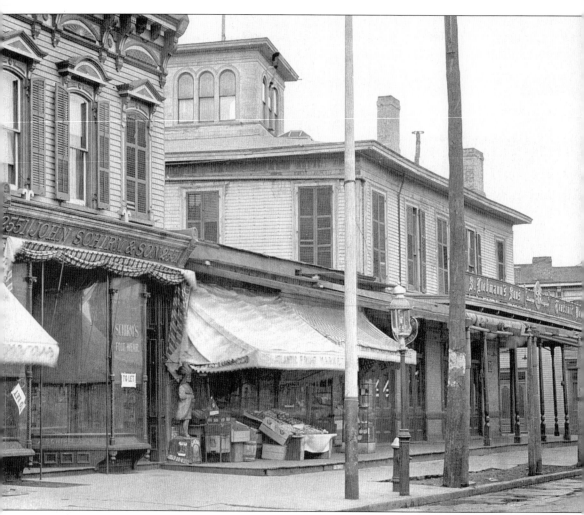

A distinctive cupola identifies the Howard House as it stood on the northwest corner of Atlantic Avenue and Alabama Avenue in East New York, Bedford-Stuyvesant's eastern neighbor. It was once a flour and feed store, and Philip Howard Reid converted it into a hotel, which in later years became a transfer point for stages and trolleys traveling between Brooklyn, Jamaica, and resorts in Far Rockaway. Reid is a descendant of innkeeper William Howard, who was forced to help the British on August 27, 1776, during the Battle of Brooklyn. (Courtesy of Brian Merlis.)

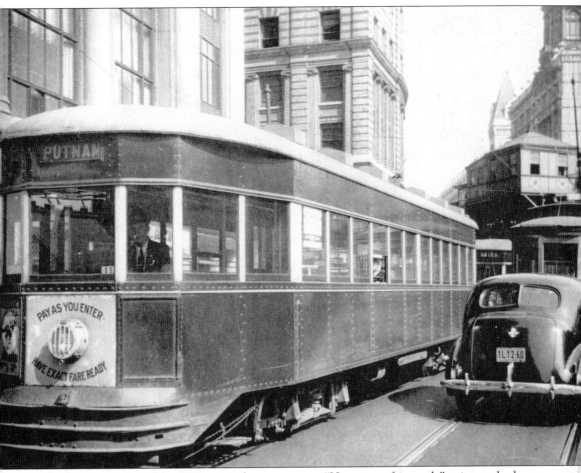

The Putnam trolley of the 1930s reminds passengers to "Have exact fare ready" as it travels along Court Street on its way to Bedford-Stuyvesant. The booth for the elevated Fulton Street train line sits perched above the downtown traffic, marking an additional option for anyone traveling to Bedford. In the distance is the distinctive steeple of Brooklyn's Central Post Office building. (Courtesy of the New York Transit Museum.)

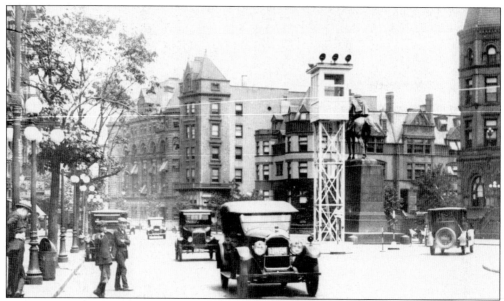

The traffic tower was once used to prevent traffic jams and manage the flow of vehicles on Brooklyn's busiest streets. The cars in Bedford's Grant Square seem to be moving well through this juncture where Bedford Avenue and Rogers Avenue (once named Perry Street) converge.

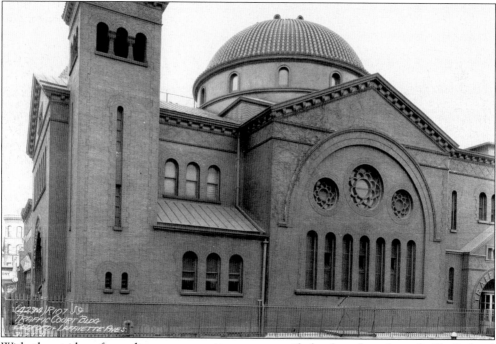

With the strides of speedier transportation came specified rules of conduct. Bedford's local traffic court, located on the corner of Bedford and Lafayette Avenues, enforced those rules. The now-demolished building once housed Temple Israel, founded in 1869 and in 1905, one of Brooklyn's Jewish congregations with 600 members. Later united with Beth Elohim to form Temple Israel, it is today located on Eastern Parkway, east of Flatbush Avenue. (Courtesy of the New York Historical Society.)

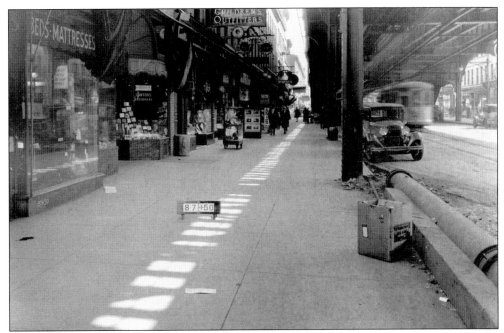

The elevated tracks of the Fulton Street train line provide rapid transit for its passengers but cast a deep shadow over the neighborhood stores. A bit of sunlight still manages to filter through onto the streets below, illuminating some of the wares exhibited in wheeled display cases by the local merchants. (Courtesy of the New York Historical Society.)

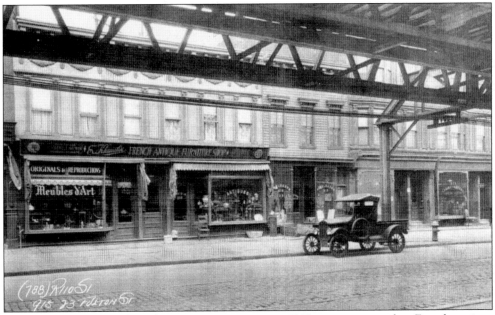

Caught by the camera's lens during a quiet moment in 1929, a car sits outside a French antique furniture shop at 917 Fulton Street. The Fulton Street elevated train will soon rumble overhead, and the clang-clang of the Fulton Street trolley will announce its presence on the cobblestoned track beds. Not one of these three transportation modes existed before 1885. (Courtesy of the New York Historical Society.)

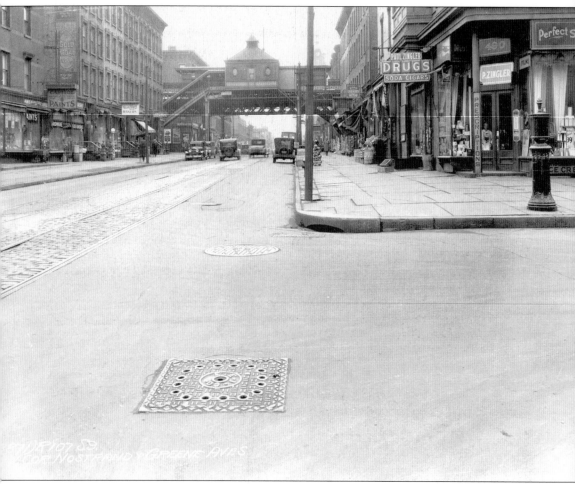

In this view looking south on Nostrand Avenue in 1931, the cabin housing the elevated Lexington Avenue train clerk is a reminder of a now-vanished era. The el line is gone, the defunct trolley tracks are covered in asphalt, and the old-fashioned fire alarm box (right) no longer stands on Brooklyn street corners. Only the IBM building in the distance (to the right of pole) at Nostrand and Gates Avenues still remains. (Courtesy of the New York Historical Society.)

The Nostrand Avenue trolley takes on a more modern appearance in the 1940s. Longer in body, and equipped with both front entry and back exit doors, this trolley model sits at the DeKalb Avenue carbarn before departing for its Reid/Nostrand Avenue run.

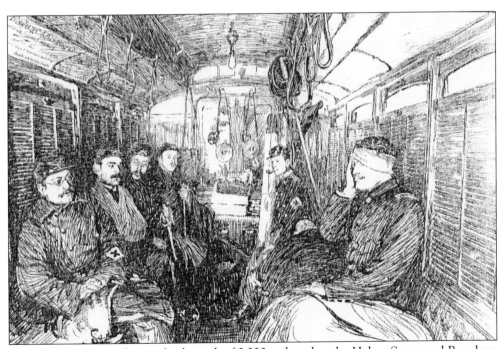

The 1895 streetcar strike involved a mob of 3,000 gathered at the Halsey Street and Broadway stables caused then-mayor Charles Schieren to call out the National Guard to keep order, which included Bedford's 13th Regiment. During the melee that ensued, a number of soldiers were injured and then treated in a trolley car used as a makeshift ambulance.

Today many transportation choices are available for anyone traveling to Bedford-Stuyvesant, including the A, C, and G trains; the Broadway-based J, M, and Z trains; as well as the No. 3 and No. 4 lines in the formerly identified neighborhoods of Weeksville and Crown Heights. A variety of buses are also convenient for travel.

Bedford's colonel Marshall Lefferts (born in 1825) was commander of the well-regarded 7th Regiment, a unit summoned to the front on three occasions during the War of the Rebellion. Although not actively engaged on the field, many of its officers and privates served in the war. Lefferts was president of the Gold and Stock Telegraph Company when he died from a sudden heart attack in 1876. He was on his way to Philadelphia to command the 7th Regiment Veteran Guard.

Jefferson Avenue was a popular thoroughfare in the days when parades were a regular part of holiday celebrations. Here regimental winners of an artillery competition display their commemorative trophy on Jefferson Avenue near the corner of Nostrand Avenue in the 1920s. (Courtesy of Brian Merlis.)

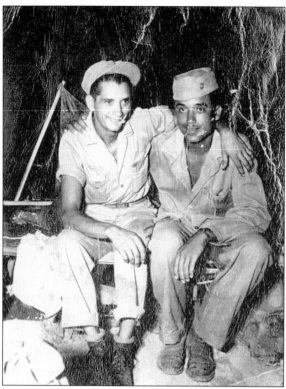

In a chance meeting during World War II, brothers-in-law Alan Ross (left) and Eugene Jenkins posed for this picture of more than 60 years ago. Both men were recruited from the Bedford-Stuyvesant neighborhood and following the war returned to their homes on Jefferson Avenue and Hancock Street.

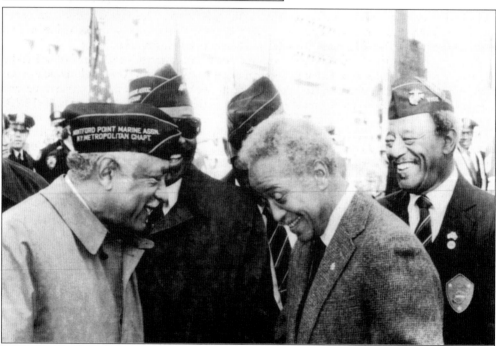

United States marine veterans of World War II, including John W. Hamlin (left) of Bedford-Stuyvesant, share a moment with fellow marine New York City mayor David Dinkins during Veterans Day services at city hall in 1992.

Seven

COMMERCE

From its earliest years, Bedford has enjoyed long periods of flourishing commerce and manufacture. Its most prominent citizens and largest landholders created Bedford farms to feed the hungry and growing population in Manhattan. These early Dutch farmers like the Lefferts, Suydam, Remsen, Valdervoort, and Havens families ultimately prospered in their determination to meet those needs.

By purchasing large tracts of land, these investors with their African slaves (totaling 72 in 1790) cleared the fields, raised the produce, and delivered the needed goods to the Brooklyn and Manhattan waterfront with great success. Many held onto their acreage until the 1880s and 1890s. In the end, their descendants would witness the passing of an era as architects and developers replaced the old farms with solid and beautiful brownstone buildings.

The property of Judge Leffert Lefferts was one of the last farms to be sold in Bedford under the terms of the Lefferts will. Commonly recognized as the "North Farm," all obstacles were removed in 1878 with the sale of land lying between Bedford and Stuyvesant Avenues on one side, and Halsey and Putnam Avenues on the other. This 90-acre plot ultimately yielded 1,400 city lots. The North Farm was originally purchased by Judge Lefferts's father for 1,282 pounds 10 shillings from Cornelius Vandenhoeven and was, at its 19th-century sale, considered to be "of vast material benefit to Brooklyn as . . . seven (transportation) lines run near or through (the site), or connect them with the ferries."

Beautiful apartment buildings constructed in the 1890s were designed for the affluent middle class of the period, the most noteworthy being the Alhambra Apartments on Nostrand Avenue and Macon Street, the Renaissance Apartments on Nostrand Avenue and Hancock Street, and the Imperial Apartments on Pacific Street and Bedford Avenue. Today all three buildings have been refurbished and are still standing.

A choice of local hotels was once an option for visitors to Bedford, and the eight-story Brevoort Hotel on Bedford Avenue and the southwest corner of Fulton Street was one of the area's best. Hotel Chatelaine, an apartment hotel with fireproof construction and soundproof walls and floors, was sold in 1930 for conversion as the Swedish Hospital. Today it is a newly renovated apartment building, with the green-patina lettering of the Hotel Chatelaine still displayed on its side.

This upper-middle-class neighborhood, with its beautiful homes and convenient transportation to destinations like downtown Brooklyn, the ferry terminal, and Manhattan attracted residents like Abraham Abraham (owner of Abraham and Straus Department Store), F. W. Woolworth (owner of the five-and-ten cent chain), and John C. Kelley (manufacturer of water meters and member of the Brooklyn Board of Education) as the place to live.

H. C. Bohack had resided at 806 Quincy Street, a beautiful mansion that is now home to the Varick Memorial AME Zion Church. The Bohack chain once proliferated in the Bedford-Stuyvesant neighborhood, as well as Brooklyn, Queens, and Long Island. The commercial thoroughfares of Fulton Street, Nostrand Avenue, and Tompkins Avenue were also successful locations for stores like Trunz, Chock Full O' Nuts, and Bickford's in the 1930s, 1940s, and 1950s.

Sheffield Farms ran a processing and bottling plant on Fulton Street near Nostrand Avenue, with a retail store just steps from the plant.

The Rubel Coal and Ice chain was a successful business in Bedford-Stuyvesant for many years but met its demise with the introduction of oil heat and electric refrigeration after World War II. Small local businesses like Beaty Fuel Oil on Fulton Street, owned by a local resident of color, eventually replaced the heating and cooling giant.

The American Merri-Lei on Halsey Street was another remarkable business in the neighborhood. For years, beautiful and welcoming leis were assembled in Bedford-Stuyvesant at numbers greater than any other manufacturer in the world, including Hawaii. Bunny Studios, the popular photographer of choice for people of color, held space at 548 Nostrand Avenue near Herkimer Street for many, many years.

In 1941, Clyde Atwell founded the Paragon Progressive Credit Union to service the financial needs of local black residents seeking mortgages and home improvement loans at reasonable interest rates. This alternate financial institution at 1475 Fulton Street provided a huge service over the 39 years of its existence and can be credited with playing a large role in securing a then-faltering neighborhood.

The loss of businesses and manufacturing jobs in the 1950s, 1960s, and 1970s was experienced throughout Brooklyn and significantly affected the economic health of the borough. Brooklyn manufacturers once included Rheingold Beer, Schaefer Beer, Barton's Candy Corporation, Borden (Drakes Cakes), Detecto Scales, Eberhard Faber (pencils), Ideal Toys, Kentile Floors, Kirsch Beverages, Pfizer, and Piel Brothers (beer).

In today's Bedford-Stuyvesant, the successful restaurant chain Applebee's is newly installed on the site of the former Sheffield Farms, the headquarters of Bedford-Stuyvesant Restoration Corporation. The Fulton-Nostrand United Merchants Association is just one of the local organizations now realizing success in bringing businesses and patrons to the community.

The Wallabout Market, which sat next to the New York Naval Hospital (in background) at the Brooklyn Navy Yard at Clinton Avenue, was created for the merchants on Fulton Street whose early-morning deliveries disturbed local residents. The Caton Cemetery (also known as Wallabout Cemetery) formerly occupied this site but was vacated under an 1847 law forbidding further burials within city limits. With the outbreak of World War II, the navy yard's need for additional space forced the market to move to Canarsie.

The steps to the Fulton Street elevated train in 1930 advise ascending riders to "Fight Acid Poisoning" by using Milnesia Wafers, an improved form of milk of magnesia; while a newspaper stand, adorned with gum-ball dispensers, commands passersby to Read The Sun. In the next block is a competing marketing message: Read The Eagle Everyday. (Courtesy of the New York Historical Society.)

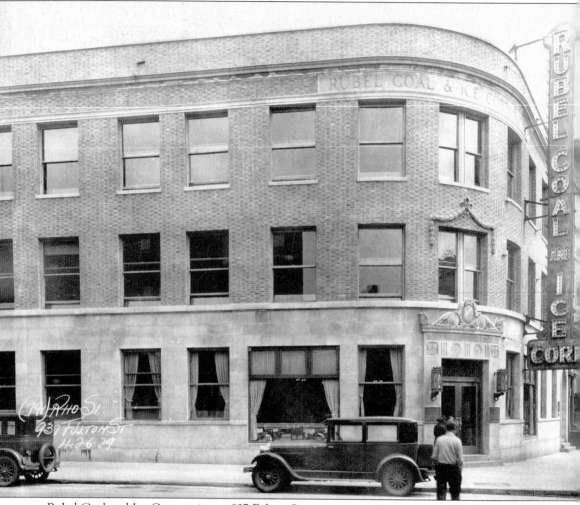

Rubel Coal and Ice Corporation at 937 Fulton Street ran an active year-round business in 1929. The sounds of coal rumbling down cellar chutes and vendor shouts of "Iceman!" as they traveled Brooklyn streets are now distant memories. Clean gas heat and frost-free refrigerators have long since replaced the coal stove and kitchen icebox. (Courtesy of the New York Historical Society.)

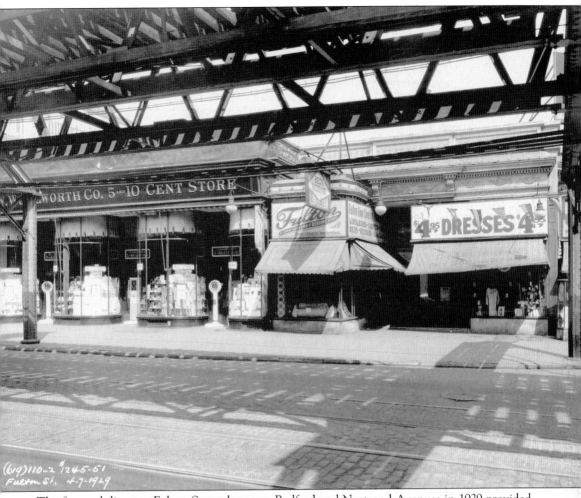

The five-and-dime on Fulton Street between Bedford and Nostrand Avenues in 1929 provided affordable merchandise for the masses. Dry goods, cookie jars, lunch counter service, and nuts and candies by the pound were just a few of the items offered in the once unique one-stop shopping venue. Its 1983 closing marked the demise of a veritable American icon. F. W. Woolworth himself once lived just blocks from this Bedford-Stuyvesant store on Jefferson Avenue. (Courtesy of the New York Historical Society.)

The former home for F. W. Woolworth at 209 Jefferson Avenue (right of light building) still stands at its tree-lined location between Nostrand and Marcy Avenues.

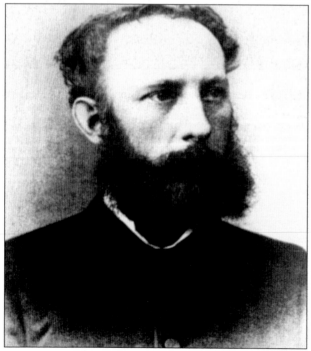

Henry Lefferts Brevoort, the offspring of two venerated Bedford families (J. Carson Lefferts and Elizabeth Dorothy Brevoort), was cofounder and president of the Brevoort Savings Bank. A liver ailment caused his early death in the early 1900s.

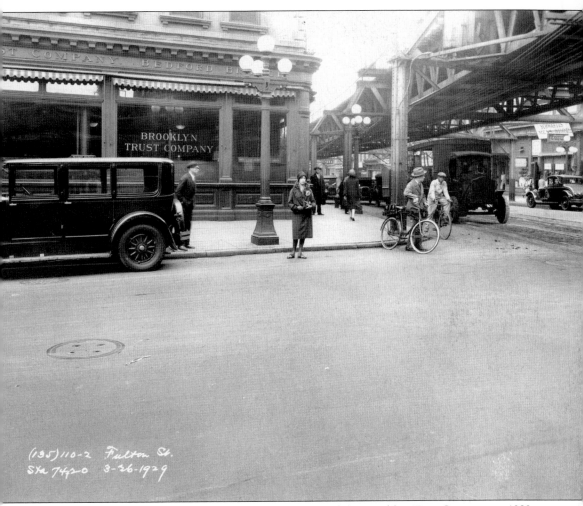

This structure at Bedford Avenue and Fulton Street housed the Brooklyn Trust Company in 1929, and the trust company housed the funds of its Bedford residents, including those of the Lefferts and Brevoort families who lived nearby. When the family farms were sold off in the 1890s, the proceeds were held by this banking institution. (Courtesy of the New York Historical Society.)

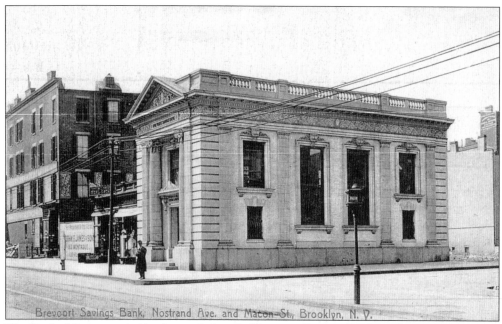

Brevoort Savings Bank, Nostrand Ave. and Macon St., Brooklyn, N. Y.

The first building occupied by the newly founded Brevoort Savings Bank was located at Nostrand Avenue and Macon Street, diagonally across the street from Girls High School. In later years, Brevoort bank relocated around the corner into the renovated Fulton Theater just steps from Nostrand Avenue. (Courtesy of Brian Merlis.)

Today Carver Bank occupies the Brevoort Savings Bank building on Fulton Street, near the 26 Brevoort Place home of the Brevoort-Lefferts family, and in the same block as the former Rem Lefferts home at Arlington Place, and the Leffert Lefferts house at 1224 Fulton Street. A panel covers the etched-stone building header identifying the above structure as once being the Brevoort bank.

In the critical 1950s and 1960s, when people of color had difficulty gaining bank loans and redlining forced bankers to deny applications, the Paragon Progressive financial institution provided an independent source for blacks seeking home mortgages. Founded in 1941 and located at 1473 Fulton Street, the institution closed its doors after 39 years of providing financial stability to the neighborhood.

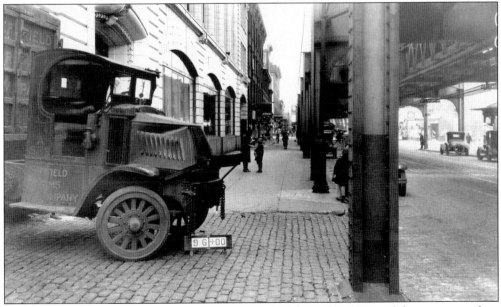

Milk was the beverage of choice for both children and adults in the 1930s, and the processing plant of Sheffield Farms Milk Bottling Plant ran a thriving business from its Fulton Street and Marcy Avenue location. The plant closed in the 1960s, a move that compounded the economic depression of both the neighborhood and borough. (Courtesy of the New York Historical Society.)

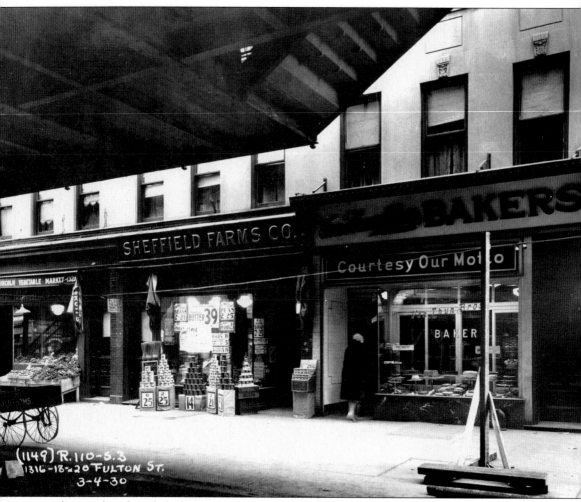

The retail outlet of Sheffield Farms Company at 1318 Fulton Street, just two doors from the processing plant, sold not only milk and butter, but groceries as well. With the October 29, 1929, stock market crash, patrons and businesses would feel the effects of a national depression until the start of World War II. (Courtesy of the New York Historical Society.)

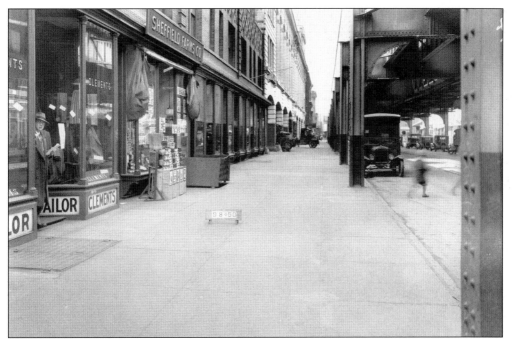

In this 1929 photograph, Sheffield Farms delivery trucks parked at the company's loading dock extend onto the Fulton Street sidewalk. The elevated train, constructed in 1885, casts a shadow over the stores and streets that appear remarkably underpopulated. (Courtesy of the New York Historical Society.)

A recent photograph from the same 1929 perspective captures a renovated Sheffield Farms building that today houses the Bedford-Stuyvesant Restoration Corporation founded in 1967. The A-train subway travels the underground route of the now-demolished elevated train taken down in the 1940s.

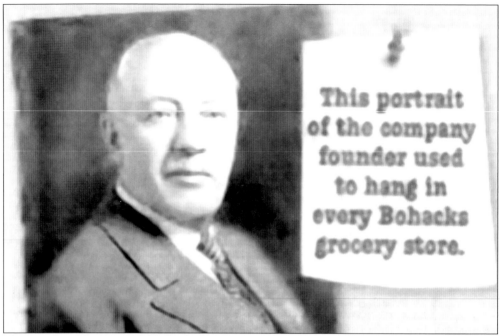

This portrait of the company founder used to hang in every Bohacks grocery store.

The founder of the successful Bohack chain, H. C. Bohack (1866–1931), once lived at 806 Quincy Street in a large mansion near Ralph Avenue. He emigrated from Germany in 1883 during the same year that Max Trunz and F. W. Woolworth came to America, merchants who also once lived in Bedford-Stuyvesant.

The Varick Memorial AME Zion Church has resided at this 806 Quincy Street address for the past several decades.

Eight

ENTERTAINMENT

The early settlers of Bedford found a number of ways to relax and entertain themselves. The Pinkster holiday was observed by Dutch families and, in a spring tradition, large quantities of shad were caught in the bay, purchased from local fishermen coming to shore, and salted for winter use.

During *Paasch*, an anniversary kept by the St. Nicholas Society, children collected and colored fresh eggs to be cracked by master, mistress, youngsters, and the children of former slaves. Follies, balls, sleigh rides, concerts, and lectures were also popular amusements during the 19th century.

Horseback riding was enjoyed by many Bedford residents, and in the 1840s, pleasure was found in taking the reins at the old-fashioned mansion at Bedford and Lafayette Avenues, riding along the Clove Road to Flatbush, and onto the ocean shore near the residence of a former black slave named Bounty. He owned waterfront property near a popular fishing ground, and his family became rich when it was sold after Bounty's death.

Ice-skating became the craze in the 1860s, and a number of natural and created skating resorts were popular at this time. The Nassau Pond was located on Clove Road and was accessible by the "Flatbush cars" that passed within a stone's throw of the pond. It was the oldest skating pond in the vicinity, in use even before skating clubs existed in Brooklyn. A large building on the margin of the six-acre pond offered refreshment, saloons, and restrooms. The pond was situated in the center of a large field and enclosed by a fence, and locals were still allowed to visit the pond for free.

Other natural ponds included the Chichester in Williamsburgh, the Monitor in Greenpoint, and the Yukatan in Bedford. Suydam's Pond, located on the Hunterfly Road, was frequented by the K.N. Club, one of many skating clubs that became active in winter. It later merged into the Capitoline Club (organized in 1862) at a large artificial skating rink located between Putnam Avenue, Halsey Street, Marcy Avenue, and Nostrand Avenue. In summer, it doubled as a popular baseball field.

The opening of the Brooklyn Ice Palace on January 14, 1917, was received enthusiastically. Located on Atlantic and Bedford Avenues and measuring 200 feet by 85 feet, the 17,000-square-foot palace was the largest rink in Greater New York and fifth largest in the world. It was the home rink of the Crescent Athletic Club and had a seating capacity for 1,000 people, expanded in 1918 to accommodate 2,500.

Theater entertainment abounded in Bedford and Brooklyn during the late 19th and early 20th centuries. Al Jolsen is said to have performed at the Bedford (on Dean Street and Bedford

Avenue) as did neighborhood resident Frannie Brice (née Borach), who was reportedly discovered during an amateur night presented by theater owner Frank A. Keeney.

In time, moving and then talking pictures, offering affordable double features, replaced the live theater shows. The local Brevoort, Gaiety, Auditorium, Apollo, Fulton, Throop, and Gates Theaters, located just a few minutes walk from each other, were all financially profitable.

Dinner and dancing were also an enjoyable way to spend an evening in the 1930s and 1940s, and vintage photographs show many Chinese restaurants with signs to this effect. Bulb-lit signage affixed to building exteriors popularly announced "Chop Suey and Dancing" in Bedford-Stuyvesant during this time. This is reinforced by early television episodes of *The Honeymooners*, as Jackie Gleason's character, Ralph Cramden, and wife, Alice, would occasionally enjoy a night out in this way. It is interesting that the fictional Cramdens lived on Chauncey Street, a well-recognized avenue in Bedford-Stuyvesant.

Prior to World War II, armories hosted crowds of big band–music fans who danced to the popular rhythms of the day. The 23rd Regiment Armory on Bedford and Atlantic Avenues and the 13th Regiment Armory on Putnam and Throop Avenues were venues for the swinging sounds of Count Basey and many other iconic bands of their caliber.

During those years, and in the postwar period that followed, a proliferation of quality supper clubs made Bedford-Stuyvesant the hot spot to catch the talents of future jazz greats. Turbo Village on Reid Avenue and Halsey Street, Sonia's Ballroom on Putnam and Bedford Avenues, and the Arlington Inn on Fulton Avenue and Arlington Place were three of many venues where live performances by Dizzy Gillespie, Miles Davis, Randy Weston, Max Roach, Willie Jones, Charlie Parker, Thelonious Monk, John Coltrane, and Charlie Mingus (to name a very few) could be enjoyed.

Putnam Central was founded in 1945 as a private club for men of color with the goal of promoting social welfare and community spirit in Bedford-Stuyvesant. The popular club, at 65 Putnam Avenue and headed by Frederick W. Eversley, soon achieved a membership of 2,200 men. In 1950, a campaign was conducted to collect funds for the Bojangles Free Day Nursery, named for the popular tap-dancing entertainer and designed to assist working mothers in the day care of their children. The early French Renaissance brownstone, built in 1889 and designed by architect R. I. Daus of Brooklyn, contained a dining room, assembly hall, lodge room, café, reading room, card room, meeting room, and cocktail lounge. The building still stands today and is occupied by the Independent United Order of Mechanics World Headquarters.

In the later years of the 1960s, live popular entertainment could be found at the Brevoort Theater on Brevoort Place and Bedford Avenue. On weekends, the recording stars of the day performed their giant hits before packed and enthusiastic crowds. Stevie Wonder, James Brown, Smokey Robinson, Martha and the Vandellas, and the Shirelles are just a few of the talents that once graced the local theater. Demolished in the 1970s, the theater once shadowed the Brevoort mansion lot. The Brevoort family home was taken down a decade before.

In more recent years, the African Street Festival, formerly the Afrikan Street Carnival, celebrates the goods, food, clothing, crafts, and culture of Africa. Begun in 1976 as part of the commencement exercises of the Uhuru Sasa School, it became too large for the school grounds and moved its location to today's Boys and Girls High School on Fulton Street near Utica Avenue. Having outgrown that facility, the five-day cultural event, attended annually by 6,000 people, is now held in downtown Brooklyn and presently ranks as the largest Afrocentric festival in the United States.

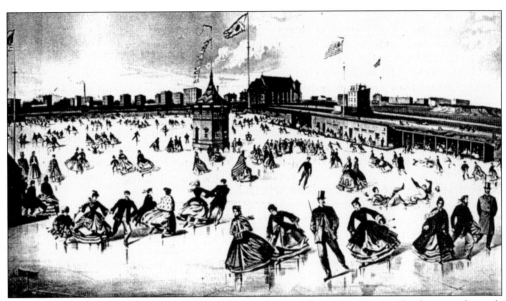

Ice-skating became all the rage in the 1860s, and many skating resorts on both natural ponds and artificial rinks suddenly sprang up to service individual enthusiasts and skating clubs. These included the Nassau Pond on Clove Road, the oldest skating pond in the vicinity, as well as the Yukatan in Bedford, Suydam's Pond on Hunterfly Road, and Chichester's Pond (also known as Cooper's Pond) in Williamsburgh. When the competing Union Pond (shown above) opened in Williamsburgh in 1862, many New Yorkers came over on the Grand Street ferry to patronize it.

Skating was still popular when the Brooklyn Ice Palace opened on January 15, 1917, at Bedford and Atlantic Avenues. The ice surface was 200 feet long by 80 feet wide, making it the largest artificial rink in Greater New York and the fifth largest in the world. Home to the Crescent Athletic Club, it seated 1,000 people and offered classes in both simple and fancy skating. The 1885 *Skaters' Gazette* was a free handout to its patrons. (Courtesy of Brian Merlis.)

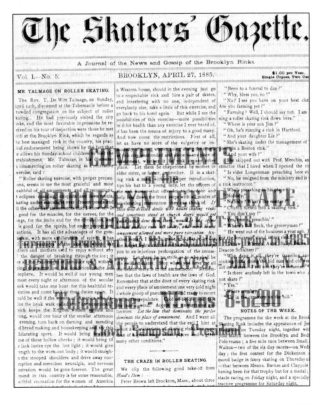

Neighborhood resident and accomplished skater Catherine Hamlin was a regular Ice Palace patron in the early 1940s. She poses here in her custom-made skates at the well-known Bunny Photograph Studio. Located at 548 Nostrand Avenue, between Fulton and Herkimer Streets, Bunny was the studio of choice for people of color wishing to capture significant commemorative moments.

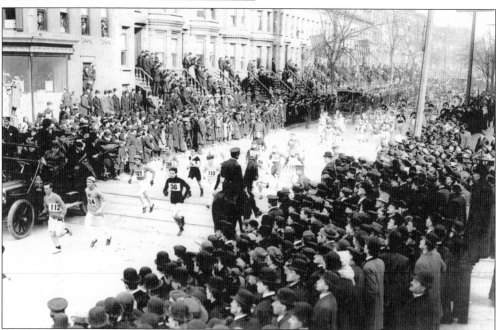

A sea of bowlers and woolen overcoats help to warm the spectators as they crowd sidewalks, stoops, and stairs for this annual event, as marathoners travel up Jefferson Avenue and cross Sumner Avenue on February 12, 1909. Clad in shorts, sweaters, and gloves, the runners appear oblivious to the weather. (Courtesy of Brian Merlis.)

Biking has remained a popular form of entertainment for children over the years, and the lines of this three-wheeler were typical of the 1920s era. Here a young cyclist pauses under the Bedford-Stuyvesant Fulton Street el train to consider the photographer, while his companion appears to wait patiently for a turn to ride. (Courtesy of the New York Historical Society.)

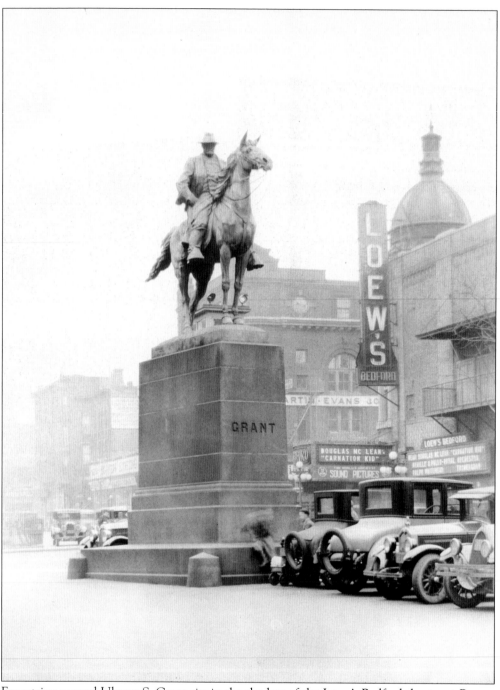

Equestrian general Ulysses S. Grant sits in the shadow of the Loew's Bedford theater at Rogers Avenue and Bergen Street in 1931, a venue once owned by Frank A. Keeney. A 1906 amateur night contest at one of Kenney's three theaters, believed to be the Bedford (pictured here), brought neighborhood talent Fanny Brice to Keeney, who helped launch her career. Loew bought the Keeney Bedford in 1924. (Courtesy of the Brooklyn Historical Society.)

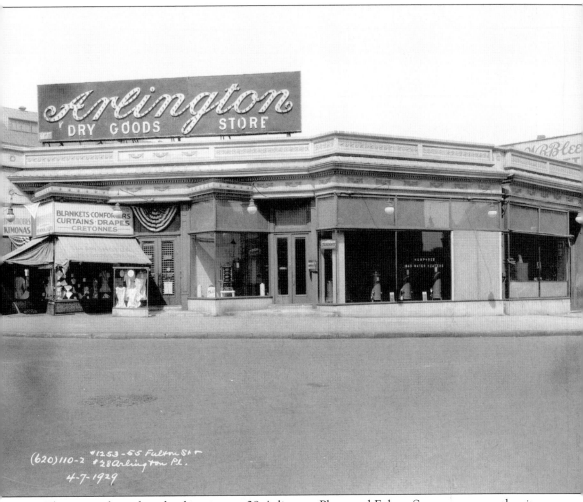

There is no hint that this location, at 28 Arlington Place and Fulton Street, was once the site of the Revolutionary War home of Rem Lefferts, demolished in 1893. In 1929, the Arlington Dry Goods Store sold kimonos, comforters, and cretonnes (strong unglazed cotton or linen upholstery fabric). (Courtesy of the New York Historical Society.)

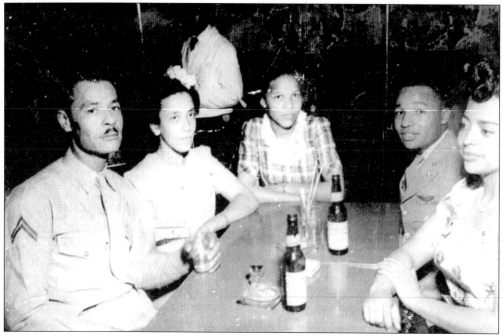

Twenty years later, the Arlington Inn occupied the historic Arlington Place site offering dinner and live entertainment. In 1945, Tuskegee airman George Rhodes (second from right) with his wife, Dorothy Hamlin Rhodes (right), and sister Clarice Rhodes Jenkins (center) enjoy leave time during World War II along with army man Leonard Bowser and his wife, Nora Jenkins Bowser. A three-alarm kitchen fire permanently closed its doors in November 1950.

Fanny Brice (née Borach), born in Newark, New Jersey, lived for a short while at Bergen Street and St. Marks Avenue, a location near the Bedford Theater in Grant Square. Performer Al Jolson also brought his blackface act to Keeney's stage in 1904.

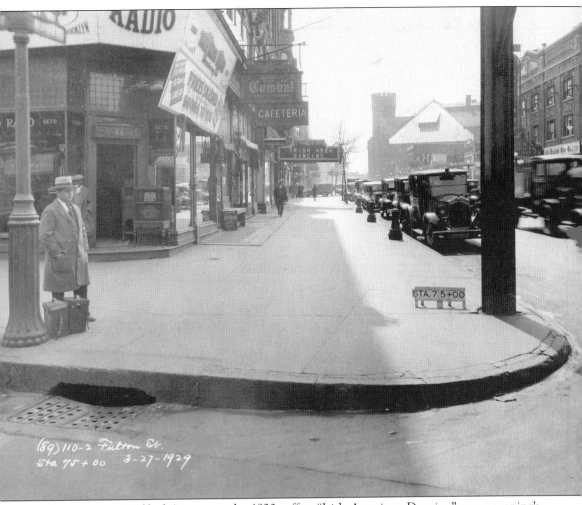

A marquee on Bedford Avenue in the 1920s offers "Irish American Dancing" as an evening's entertainment. Located less than a half-block from the old Lefferts-Brevoort Mansion, this venue sits within sight of the 23rd Regimental Armory in the near distance. (Courtesy of the New York Historical Society.)

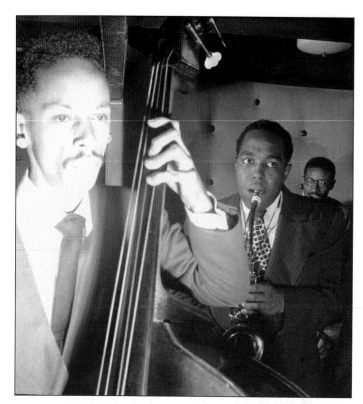

Bedford-Stuyvesant's own, bassist Tommy Potter (left) and drummer Max Roach (right), perform with saxophone great Charlie Parker at the Three Deuces in Manhattan. "The music was everywhere," according to longtime Brooklyn resident and musician Freddie Robinson. Renowned Bedford-Stuyvesant clubs dotted the neighborhood, including the Club Baby Grand, the Arlington Inn, Club La Marchall, Putnam Central, Tip Top Club, and Verona Cafe. (Courtesy of William P. Gottlieb.)

Snookey Marsh (c.1940)

Singer, dancer, drummer, and pianist Theodore "Snookey" Marsh stopped the show in the 1940s at the Verona Café at Bedford-Stuyvesant's Verona Place. An acknowledged mainstay at Manhattan's Smalls Paradise, Marsh often entertained with performers like Miles Davis, John Coltrane, and Thelonious Monk. (Courtesy of Joysetta Pearse.)

Brooklyn vocalist Billie Stewart enjoyed a rewarding career during the popular jazz era of the 1940s and 1950s. With a voice that matched Billie Holiday's, she recorded two hits under the Savoy label, including "In My Solitude." It was the B-side "Gloomy Sunday" that brought her fame for the number of listener suicide attempts it sparked. (Courtesy of Joysetta Pearse.)

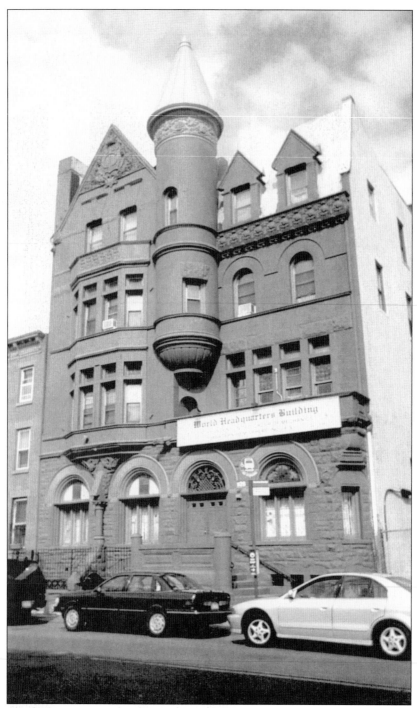

Founded in 1944, Putnam Central at 65 Putnam Avenue was a men's organization where people of color could enjoy a social setting of dining, dancing, and live entertainment without an atmosphere of discrimination. According to jazz great Randy Weston, "Putnam Central was the spot because everybody was there: Dizzy, Miles, Leo Parker, John Lewis, Milt Jackson." Today the landmarked building houses the Independent United Order of Mechanics World Headquarters.

Basketball great Jackie Robinson (right), heavyweight boxing champion Floyd Patterson, entrepreneur Earl Graves, Congressman Al Vann (above, left), and musician Eubie Blake (above, right) were either native to, or residents of, Bedford-Stuyvesant.

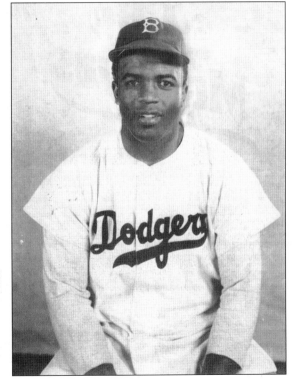

Born and raised in Bedford-Stuyvesant, young musician Randy Weston, shown here with his dad in the 1970s, would dedicate future decades to the acknowledgement and preservation of the African American legacy of jazz. Today Weston's influence at Medgar Evers College in neighboring Crown Heights is helping to eventually design a formal curriculum for a college degree in this purely American musical art form. (Courtesy of Dolores McCullough.)

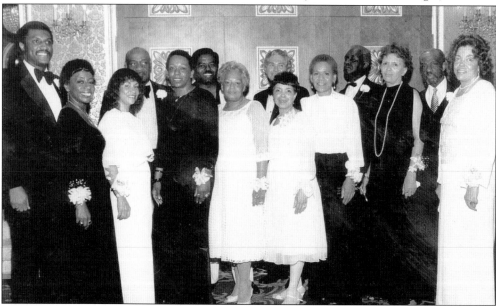

In the 1970s, present and former Brooklynites would reunite at an annual dance to renew old ties and celebrate personal successes. Social clubs flourished in the 1940s and 1950s, and this annual event was enthusiastically supported by members of the Sentimental Strollers, the Knights, the Top Hats, and the Metronnettes, to name just a few. (Courtesy of Dolores McCullough.)

Nine

PRESERVATION

It is an unfortunate fact that many beautiful and historic homes in Bedford-Stuyvesant have been demolished over the years. The Bloom/Turnbull/Lefferts house at 1224 Fulton Street was standing in 1776, rebuilt in 1787, and bought by Leffert Lefferts in 1791. It was taken down in 1909. It is told that Revolutionary War generals William Howe and Charles Cornwallis paused in front of this home before heading south to engage in the Battle of Brooklyn. The home also contained a narrow back stairway that led to a room with barred confines reportedly used to punish errant slaves prior to New York's 1827 emancipation act.

A small cabin stood in the back of this same house. Having once served as living quarters for the enslaved, it was later used by the Lefferts servants as a summer kitchen and was lost when they demolished 1224 Fulton Street.

The Howard halfway house at Broadway and Fulton Street was an inn where the British forced William Howard to lead the way through the thick woods on the way to fight the patriots in the Battle of Brooklyn. A maze of steel beams, constructed to support the elevated Fulton Street line and the connecting J, L, and N trains, now stands in this unmarked historic location.

The original Lefferts homestead, near 728 Bedford Avenue opposite the old Public School No. 3, and the Lambert Suydam House on the north side of Fulton Street (between Arlington Place and Nostrand Avenue) were Revolutionary War structures lost by the mid-1850s.

A famed 100-foot well, situated on the north side of Atlantic Avenue off Bedford Avenue, once contained highly limed water that consistently restored the imbiber. It reportedly did everyone and everything good, including men, animals, and plants. The well's owner, John C. Stewart, ran the combination inn/postal stop/tavern, where horses approaching this rest stop would nicker in anticipation of the invigorating refreshment. Today the Brevoort Post Office for zip code 11216, named in (1885) for the influential local family, now occupies the former site of this 19th-century inn.

An ancient Dutch windmill used to stand on the intersection of Ellery Street (named for William Ellery, a signer of the Declaration of Independence) and Marcy Avenue. A housing project is located there today.

It should be remembered, however, that there have been some preservation successes as well. Key among these is the work of Brooklyn-native Joan Maynard (1928–2006) who dedicated years to successfully save four irreplaceable homes representative of the black community of Weeksville (established in 1852). Today four beautifully refurbished frame houses are both her legacy and the headquarters of the Weeksville Heritage Center, remarkable examples of what can be done through committed and concerted effort.

Another success story is the founding of the Bedford-Stuyvesant Restoration Corporation. The voiced concerns of Judge Thomas R. Jones in 1967 raised the commitment of New York senator Robert Kennedy (1965–1968) during a neighborhood visit. This ultimately resulted in the creation of the first organization of its kind designed to halt the deterioration of America's cities, while encouraging economic investment. Under the early leadership of executive director Franklin A. Thomas (1967–1979), Restoration Corporation still serves as a nationwide template for successful community revitalization.

In a recent phenomena, many neighborhood buildings, including churches, movie houses, roller-skating rinks, brownstones, and frame homes dating back 100 years or more, have been torn down and replaced by architecturally-inconsistent prefabricated structures. An occurrence repeated in many of the country's urban centers, dismantlement has increasingly replaced preservation, due in part to the recent redesign of the mortgage industry, and the burgeoning real estate market. As a result, much of the country's local history has been, and continues to be, lost.

Residents are urged to help preserve these local vintage structures by sharing their concerns with the author at writeme387@msn.com. By working in concert with like-minded organizations committed to preserving the stories and structures representative of our neighborhoods, the irreplaceable buildings, architecture, and history of America's towns can still be saved.

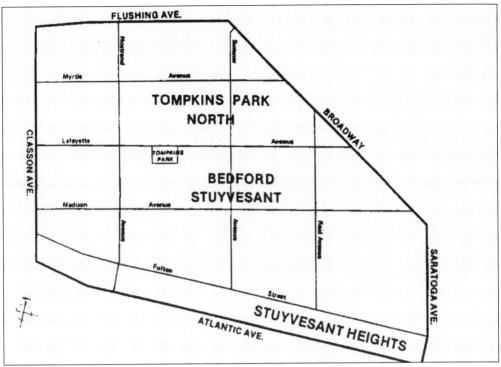

The boundaries of Bedford-Stuyvesant have shifted many times over the decades, at times encompassing the bordering neighborhoods of Weeksville, East New York, and Crown Heights. Once extending as far as Eastern Parkway, today's Atlantic Avenue now marks the southernmost border of Bedford-Stuyvesant's 2,000-acre neighborhood, a delineation that excludes some of Bedford Township's early locations and sites.

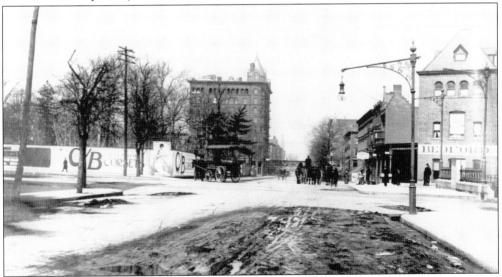

A large sign on the northeast corner of this intersection confirms that one is in the town of Bedford. Visible in the distance are the tracks of the elevated Fulton Street train constructed in 1885. The trees (at left) shelter the Lefferts-Brevoort homestead, while the Lefferts Hotel at Bedford Avenue and Fulton Street dominates the landscape. (Courtesy of Brian Merlis.)

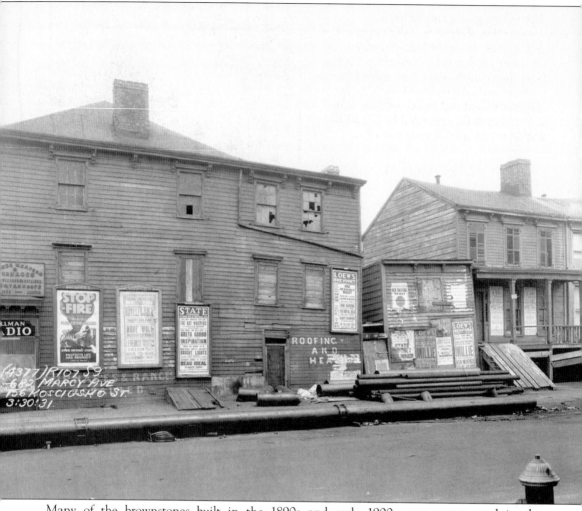

Many of the brownstones built in the 1890s and early 1900s were constructed in the southernmost sections of the Bedford-Stuyvesant grid, often on the sites of the old farms sold at that time. Lathe and wood frame houses often predominated in the northern section of the neighborhood. These old "northern" buildings located on Marcy Avenue and Kosciouszko Street typify that construction. Remarkably, a good number of frame homes still stand today, but the wrecker's ball diminishes them daily. (Courtesy of the New York Historical Society.)

The 1890s saw the simultaneous construction of three magnificent structures in Bedford-Stuyvesant, including the Romanesque Revival brownstone edifice of Boys High School and the armories for both 13th and 23rd Regiments of the New York National Guard. All three buildings were financed by dollars provided by Brooklyn taxpayers and are still standing today.

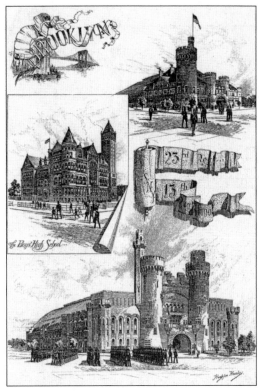

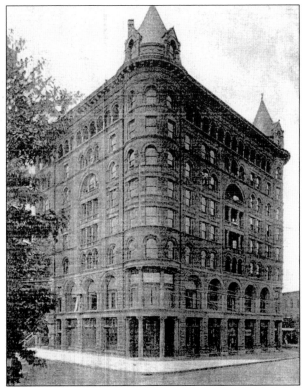

The eight-story Brevoort Building, at the southwest corner of Fulton Street and Bedford Avenue, was a landmark of the community. Financed by Henry Brevoort, the son of James Carson Brevoort and grandson of Judge Leffert Lefferts, construction totaled $100,000 and was completed in the 1880s. Occupying the entire block front on Bedford Avenue from Fulton Street to Brevoort Place, the building's lower two floors were used for business purposes, and the upper six floors were apartments.

Hattie Carthan led the effort to preserve the southern magnolia tree (*Magnolia grandiflora*), which became a symbol of the neighborhood. Originally brought from the south by stock trader William Lemken, who planted it in his 679 Lafayette Avenue front yard in the 1890s, this rare and singularly hardy specimen gained landmark status 30 years after Lemken's death in 1935 through the efforts of Carthan. (Courtesy of the Magnolia Tree Earth Center of Bedford-Stuyvesant, Inc.)

The rare magnolia tree that Lemken brought to his Lafayette Avenue home flourishes in his front yard in the 1920s. The survival of this tree, and the care it was given, earned mention in Lemken's *New York Times* obituary in 1935. (Courtesy of the Municipal Archives of the City of New York.)

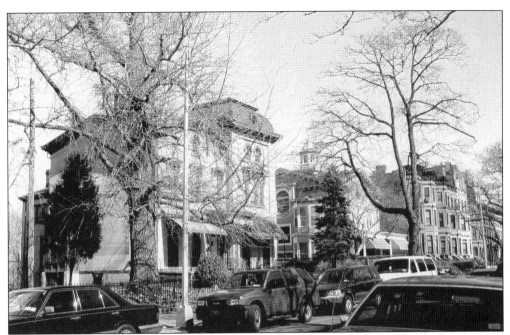

Massive sycamore trees were
felled in the 1890s (right)
when rows of brownstones
began to take their place
beside the Victorian homes
constructed decades before.
Two of these structures from
the 1860s (above) survive
on MacDonough Street
in Bedford-Stuyvesant.

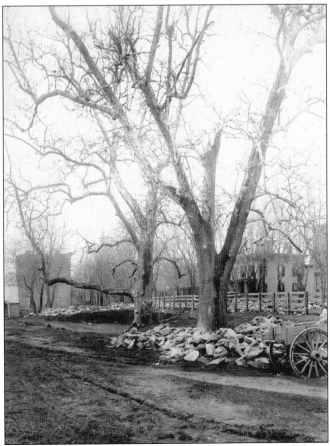

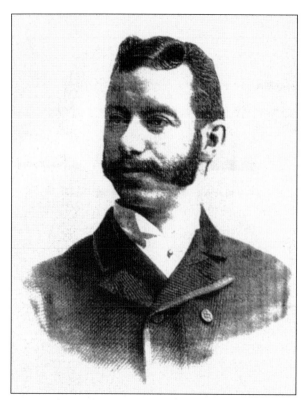

Three of the most spectacular multiunit buildings in Bedford-Stuyvesant—the Renaissance, the Alhambra, and the Imperial apartment houses—were designed by renowned architect Montrose W. Morris. A noted neighborhood resident who lived at 234 Hancock Street (now demolished), Morris also designed the Brevoort Savings Bank building on Fulton Street before passing away in 1916 at age 55.

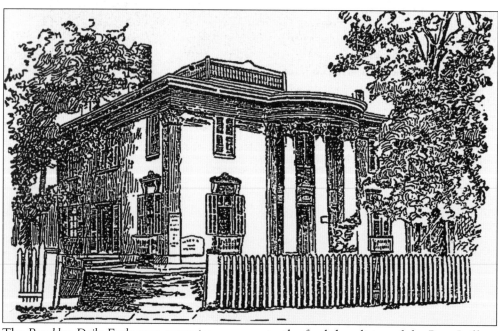

The *Brooklyn Daily Eagle* gave extensive coverage to the final demolition of the Rem Lefferts house in 1909, providing great details of the home's interior. Once situated on the corner of Arlington Place and Fulton Street, the structure represented one of the last Bedford homes that existed before the Revolutionary War.

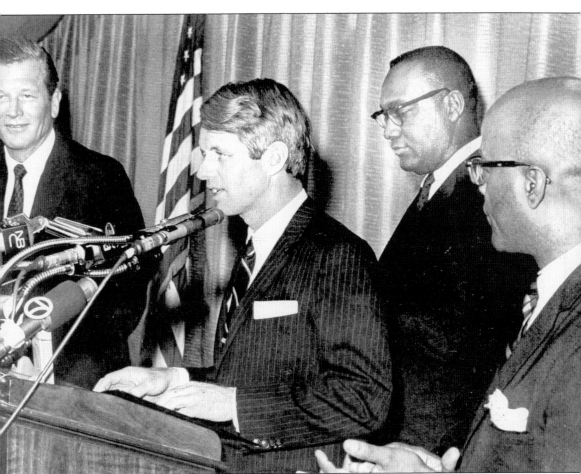

Following the challenge to address urban malaise by New York State assemblyman and judge Thomas R. Jones (right), one year later Senator Robert Kennedy and Mayor John Lindsay (left) announced the creation of the Restoration Corporation in 1967. Under the leadership of Jones, the new body received a $7 million federal grant and recruited Franklin A. Thomas (behind Kennedy) as the corporation's first executive director. (Courtesy of the Bedford-Stuyvesant Restoration Corporation archives.)

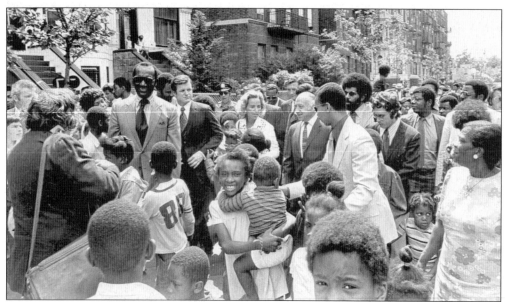

After the June 5, 1968, death of New York senator Robert Kennedy, his family continued
his commitment to Bedford-Stuyvesant. Here widow Ethel Kennedy, Senator Ted Kennedy,
Restoration Corporation executive director Franklin A. Thomas (left), and New York senator
Jacob Javitz attract a crowd as they walk the neighborhood in 1969. Thomas became the
president of the Ford Foundation in 1979, a position he held until 1996. (Courtesy of the
Bedford-Stuyvesant Restoration Corporation archives.)

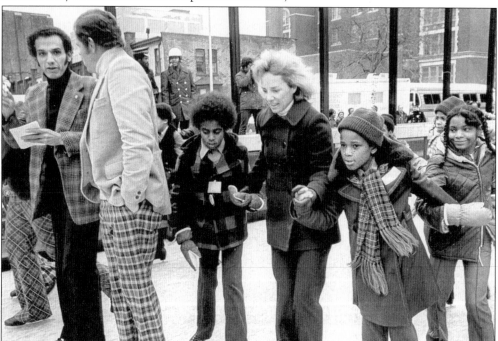

In 1970, the late senator's widow, Ethel Kennedy, attended an ice-skating party at
Bedford-Stuyvesant Restoration. Here she skates with local children at the new Restoration
outdoor rink. (Courtesy of the Bedford-Stuyvesant Restoration Corporation archives.)

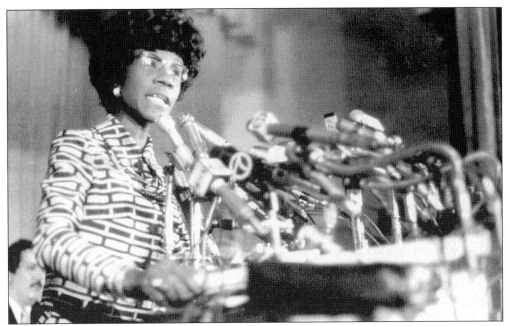

Educated at Girls High School and a graduate of Brooklyn College, Shirley Chisholm represented Bedford-Stuyvesant in 1965 as the first African American woman to be elected to the United States Congress. With an office at the Bedford-Stuyvesant Restoration building, Chisholm (with executive director Franklin A. Thomas) became the first black woman candidate for president of the United States. (Courtesy of the Bedford-Stuyvesant Restoration Corporation archives.)

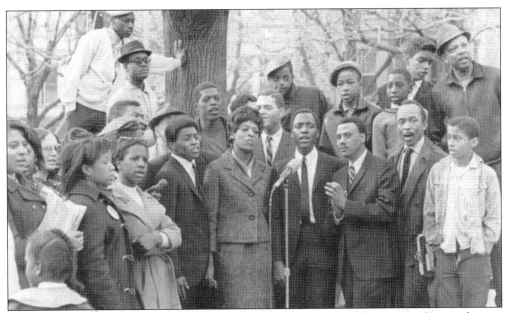

Also a Girls High School graduate, Roxie Roker (center) is a well-recognized actor, known for her role on the television sitcom *The Jeffersons* and more currently as the mother of rock star Lenny Kravitz. Here in the early 1960s, she worked on the television documentary *Inside Bed-Stuy* as a member of the WPIX staff. Roker died in 1995.

Dating back to 1662, the Clove Road was an ancient Native American trail, which later became a thoroughfare paved with cobblestones leading to early Flatbush. In the 1840s, locust trees lined the busy roadway. A small segment still existed in this 1967 view looking south from Montgomery Street between Nostrand and New York Avenues. It still remains a one-block street in 2007. (Courtesy of James Hurley.)

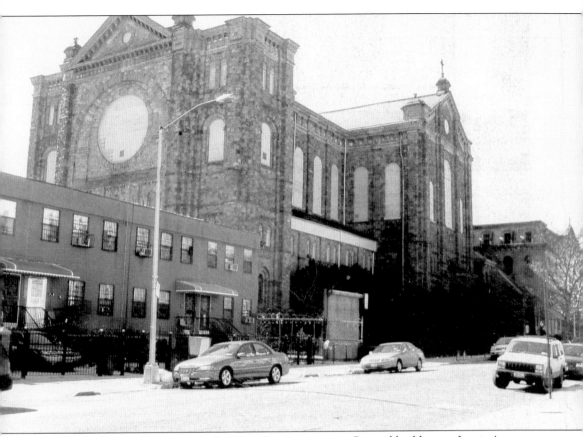

St. John the Baptist Roman Catholic Church, a Renaissance Revival building on Lewis Avenue between Hart Street and Willoughby Avenue, was built in 1870. Boarded up to protect the windows, the church's grounds originally housed St. John's College and St. John's Prep, in buildings that still stand behind this view of the edifice. New prefabricated housing now abuts the historic structure on grounds that used to be an athletic field.

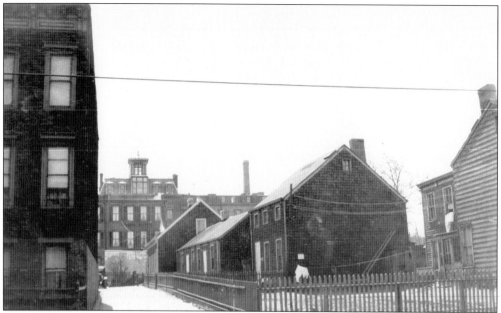

These historic frame houses, surrounded by a quaint picket fence, face Hunterfly Road, another ancient Native American trail. Saved from the wrecking ball through the efforts of Joan Maynard, these structures at Bergen Street and Buffalo Avenue represent the last remnants of the once-independent African American township of Weeksville and Bedford's Ward 9, founded in the 1830s. In the distance is St. Mary's Hospital, now closed. (Courtesy of Brian Merlis.)

In performing an archeological dig at the Weeksville Houses in the 1970s, a tintype of an unnamed woman emerged from the soil and came to represent the community's hope for uncovering long-forgotten remnants of African American history in Brooklyn. The "Weeksville Lady" is prominently displayed here at a Brooklyn Reunion Committee fund-raiser for the Weeksville Society. Weeksville Society founder Joan Maynard (right) and Pres. Audrey Phillips (center) are shown here with committee members Dr. Arthur Risbrook and Dolores McCullough (left).

BIBLIOGRAPHY

An Introduction to the Black Contribution to the Development of Brooklyn. Charlene Claye Van Derzee, curator. New York: New Muse Community Museum of Brooklyn, 1977.

Armbruster, Eugene L. *Brooklyn's Eastern District.* Brooklyn, NY: 1942.

Christman, Henry C. *Walt Whitman's New York from Manhattan to Montauk.* Lanham, MD: New Amsterdam Books, 1963.

Gallagher, John J. *The Battle of Brooklyn.* Edison, NJ: Castle Books, 1995.

Howard, Henry W. B., ed. *The Eagle & Brooklyn.* Brooklyn, NY: Brooklyn Eagle, 1893.

Jervis, Paul W. *Quintessential Priest.* Brooklyn, NY: Editions du Signe, 2005.

Kouwenhoven, John. *The Columbia Historical Portrait of New York.* New York: Doubleday and Company, Inc., 1953.

Landesman, Alter F. *A History of New Lots Brooklyn to 1887.* Port Washington, NY: Kennikat Press, 1977.

Manbeck, John B. *The Neighborhood of Brooklyn.* Yale University Press/Citizens Committee of NYC, 1998.

Ment, David, and Mary S. Donovan. *The People of Brooklyn: A History of Two Neighborhoods.* Brooklyn, NY: Brooklyn Educational and Cultural Alliance, 1980.

New York State Division of Archives and History. *Bedford Corners, Brooklyn.* Albany, NY: University of the State of New York, 1917.

O'Connor, Watson Burdette. *Bedford In Breuckelen Town from 1667 to 1868.* Brooklyn, NY: Burwey Press, 1926.

Schomburg Center for Research in Black Culture of the New York Public Library, ed. *Kaiser Index to Black Resources, 1948–1986.* Brooklyn, NY: Carlson Publishing, Inc., 1992.

Stiles, Henry R. *A History of the City of Brooklyn.* New York: W. W. Munsell and Company, 1884.

Across America, People are Discovering Something Wonderful. Their Heritage.

Arcadia Publishing is the leading local history publisher in the United States. With more than 3,000 titles in print and hundreds of new titles released every year, Arcadia has extensive specialized experience chronicling the history of communities and celebrating America's hidden stories, bringing to life the people, places, and events from the past. To discover the history of other communities across the nation, please visit:

www.arcadiapublishing.com

Customized search tools allow you to find regional history books about the town where you grew up, the cities where your friends and family live, the town where your parents met, or even that retirement spot you've been dreaming about.